FROM THE FILMS OF

Harry Potter ™

Watercolor Magic

FLORA & FAUNA

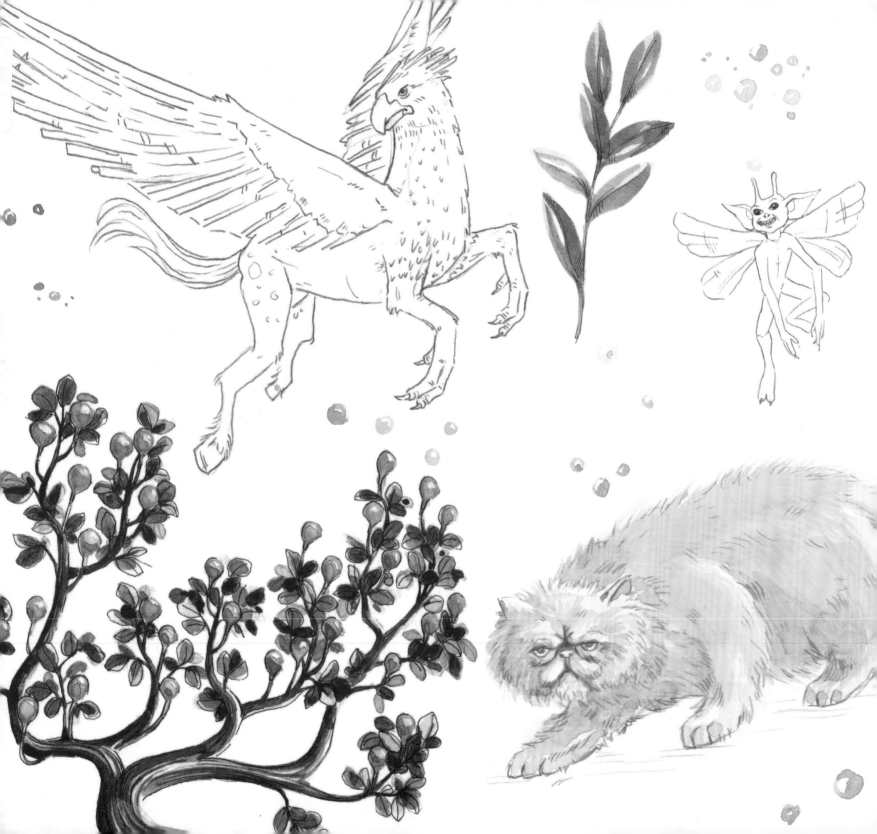

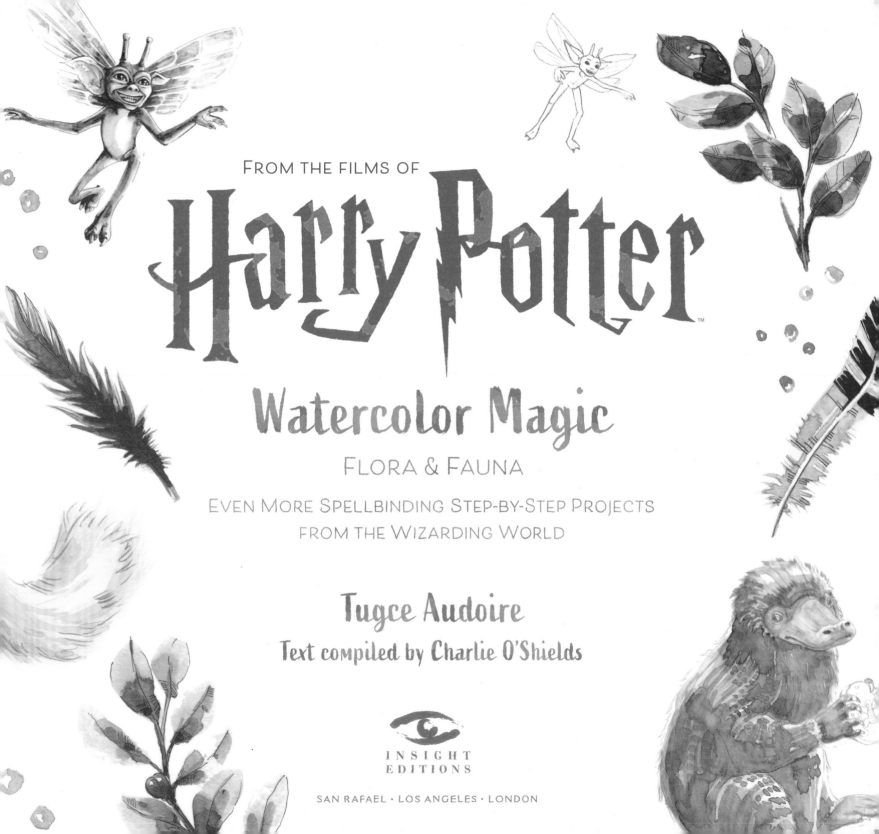

FROM THE FILMS OF

Harry Potter

Watercolor Magic

Flora & Fauna

EVEN MORE SPELLBINDING STEP-BY-STEP PROJECTS
FROM THE WIZARDING WORLD

Tugce Audoire

Text compiled by Charlie O'Shields

INSIGHT
EDITIONS

SAN RAFAEL · LOS ANGELES · LONDON

Contents

Each piece has been assigned a difficulty rating:

Simple ⚡ Intermediate ⚡⚡ Advanced ⚡⚡⚡

Introduction

Welcome to the magical Wizarding World of watercolor! I'm so happy you are joining me on this journey to create enchanting masterpieces. With your paintbrush as your wand and the paint colors as your spells, this book will help you transform the flora and fauna from the Harry Potter films into watercolor magic. Remember that there are no mistakes as you navigate through the watercolor instructions. Your work is as unique and beautiful as you are, and anything you paint is an enchanting expression of your individuality.

Whether you're new to watercolor or a fan of the Wizarding World, this book will help you practice your skills and give you the confidence to create your own beautiful and unique watercolor masterpieces.

For each piece, we provide a full-color image and step-by-step instructions, as well as the suggested color palette and supplies. The back of the book contains thirty-two corresponding sketches printed on premium watercolor paper. The removable pages make it easy to tear out the sketches, place on your workspace, and practice your watercolor skills! When you're done, your creation can easily be hung or framed.

Grab your paint and brushes, it's time to create even more Watercolor Magic!

Master Color Chart

The colors listed here are taken from the Winsor & Newton Cotman Half Pan Studio Set 45, but comparable colors from other brands will work well, too.

We've listed the base colors here, along with a few colors that are mixed from others. As you paint your own creations throughout the book, you may notice that the project palettes often list something as "Light." When you see that, it means that you should dilute the color listed with more water to create a lighter shade. And when you see "Dark," that means you should add black to the color to create a darker shade.

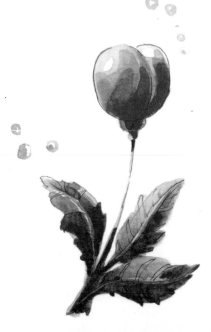

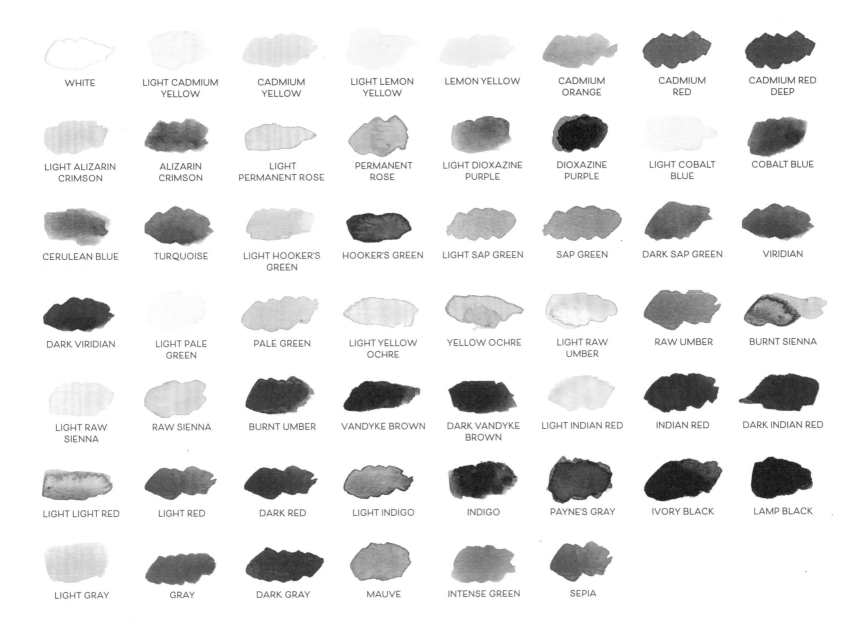

WHITE	LIGHT CADMIUM YELLOW	CADMIUM YELLOW	LIGHT LEMON YELLOW	LEMON YELLOW	CADMIUM ORANGE	CADMIUM RED	CADMIUM RED DEEP
LIGHT ALIZARIN CRIMSON	ALIZARIN CRIMSON	LIGHT PERMANENT ROSE	PERMANENT ROSE	LIGHT DIOXAZINE PURPLE	DIOXAZINE PURPLE	LIGHT COBALT BLUE	COBALT BLUE
CERULEAN BLUE	TURQUOISE	LIGHT HOOKER'S GREEN	HOOKER'S GREEN	LIGHT SAP GREEN	SAP GREEN	DARK SAP GREEN	VIRIDIAN
DARK VIRIDIAN	LIGHT PALE GREEN	PALE GREEN	LIGHT YELLOW OCHRE	YELLOW OCHRE	LIGHT RAW UMBER	RAW UMBER	BURNT SIENNA
LIGHT RAW SIENNA	RAW SIENNA	BURNT UMBER	VANDYKE BROWN	DARK VANDYKE BROWN	LIGHT INDIAN RED	INDIAN RED	DARK INDIAN RED
LIGHT LIGHT RED	LIGHT RED	DARK RED	LIGHT INDIGO	INDIGO	PAYNE'S GRAY	IVORY BLACK	LAMP BLACK
LIGHT GRAY	GRAY	DARK GRAY	MAUVE	INTENSE GREEN	SEPIA		

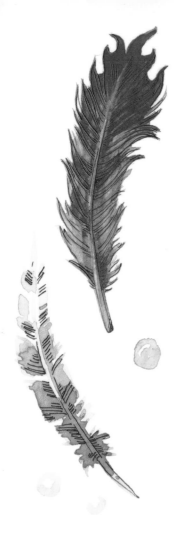

Supply List

While the brushes listed here are all Winsor & Newton Cotman brand brushes, other good-quality brushes will serve you well, too. Daler-Rowney, Raphaël, and Mont Marte all provide solid brushes to get you started. Please note that these supplies are only recommendations based on my experience. Feel free to use any alternative supplies, or ones that you are most comfortable with.

COTMAN BRUSH SERIES 111

These round brushes are great for all-purpose watercolor use. They work well for applying broad strokes of color but can also create sharp points for careful work.

Size 000 brush

Size 01 brush

Size 02 brush

Size 04 brush

Size 06 brush

Size 08 brush

Size 10 brush

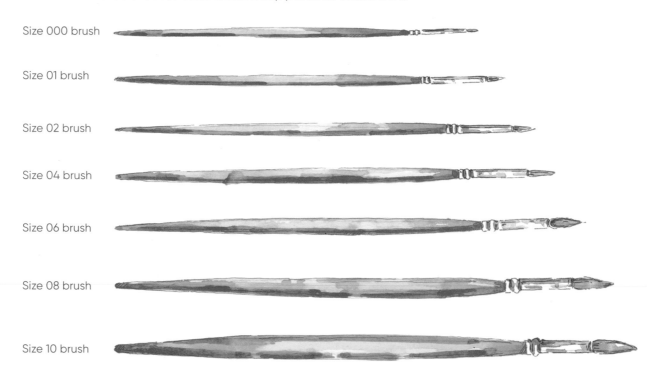

COTMAN BRUSH SERIES 666

These flat wash brushes are perfect for creating sharp edges and bold shapes.

Size 3mm brush

Size 6mm brush

Size 10mm brush

PILOT G-TEC-C BLACK GEL PEN
UNI-BALL SIGNO WHITE GEL PEN

Gel pens, in both black and white, are extremely useful for adding fine details.

Watercolor 101

BEFORE GETTING STARTED

1. Make sure you have at least two glasses of water nearby to clean your brushes: one for darker colors and the second one for brighter colors. You will need to change the water regularly to avoid muddying your paint with dirty water.

2. Have a piece of tissue or paper towel beside you at all times. Whether you're a beginner or more experienced in the world of watercolor, you may have difficulties controlling the paint and the amount of water you use. If you think that you have too much water on your paper, just use a piece of paper towel or tissue to soak up the water.

3. Have a scratch paper near you to test how your paint blends before applying the color onto your art piece.

WATERCOLOR TECHNIQUES

There are several watercolor techniques you can learn, but the main ones I mention throughout this book are:

- **Wet-on-dry technique:** For this, apply either wet watercolor paint onto dry paper, or wet paint onto a previously painted area that's completely dry. This approach allows you better control over the paint and allows for more defined edges between colors.

- **Wet-on-wet technique:** For this, apply either wet watercolor paint onto wet paper, or wet paint to a previously painted area before it dries. This is where watercolor really shines and creates beautiful and unpredictable effects as the paint flows with the water.

WATERCOLOR TIPS

- **Paint with the side of your brush**. Watercolor paper is abrasive and can ruin your brush if you paint with the tip too often. You can preserve the life of your brushes by painting with the sides of your brush instead. This will also allow better control over your brush in general.

- **Don't put too much pressure on your brush.** You can add a little pressure when you want to achieve thicker lines, but if you push too much, you can damage both your brush and the paper.

- **Clean your brush often**. Even a little bit of leftover color stuck on your brush may affect the tone of the next color you use.

- **Don't let your brushes sit in water overnight**, as this will destroy the tip of the brushes. Only leave them in clean water for a couple of minutes, rinse them thoroughly, and dry them with a tissue.

- **Mix your paint with water to activate it.** Watercolor is a water-based media, which means that it needs water to blend. Avoid using a thick layer of paint, and instead, dot the tip of your brush into the paint and mix the remaining color on your brush with some water to create a diluted mixture. Pro tip: If you have leftover paint on your palette, you can always come back and add some water to it so it's not wasted.

- **Use a palette to mix your paint.** While you are preparing your paint, always mix more than you think you need. Sometimes it can be hard to predict how much paint you will use, and it can be tricky to prepare the same mixture all over again.

- **Always test your watercolor paints.** If you are using a new watercolor set, always test the colors. Prepare a color spreadsheet with every color on your palette to see how they look on paper before starting to paint with them. Also, test how water reacts with each color. Too much water can make your paint too light or transparent, while not enough water can make it look dull and chalky.

- **Start light.** Watercolor is a transparent paint applied in layers, so start painting the lightest colors first, and then proceed to the darker colors.

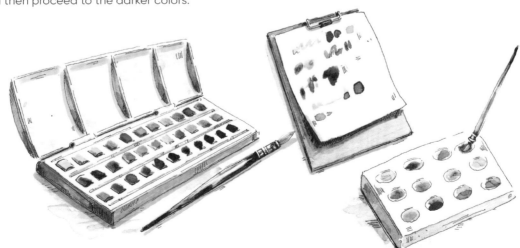

Hedwig the Snowy Owl

"Very smart owl you've got there. Arrived about five minutes after you did."

—Tom, the innkeeper of the Leaky Cauldron,
Harry Potter and the Prisoner of Azkaban

COLORS

LIGHT ALIZARIN LIGHT INDIGO INDIGO
CRIMSON

YELLOW OCHRE RAW UMBER

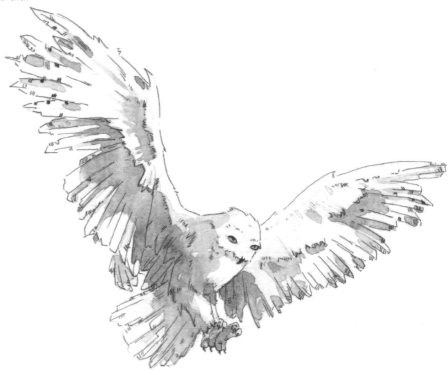

RECOMMENDED SUPPLIES

Size 04 round brush White gel pen

Size 01 brush Black gel pen

1. Using your size 04 round brush, apply light alizarin crimson on Hedwig's wings, body, and face. However, avoid applying this color everywhere, as this soft pink is necessary to make Hedwig look alive. Also, it's best to leave some white to preserve Hedwig's feather color throughout.

2. Let the first layer of paint dry completely and then add light indigo to address the first layer of shadows. Imagine the sun is shining from the top right corner of the page, so the main shadows should appear on Hedwig's left side. Ensure that you have a moderate amount of paint on your brush to control it better. While painting the wings, use your brush to accent the direction of the feathers.

3. While the light indigo layer is still wet, take some regular indigo and add it to the largest shadow areas. Again, avoid having too much paint on your brush. Using the tip of your brush, apply the paint in small dots, and let the water carry the paint around. This technique allows the two shades to mix, creating a nice watercolor effect.

4. Let everything dry completely before adding in more detailed shadows. Use the same brush and paint the shadows with indigo between the feathers, under the wings, and below the body where the shadows are the most present. When you are happy with the shading, let this layer dry.

5. Then, take your size 01 brush and apply yellow ochre to Hedwig's eyes and claws.

6. When the first layer of the claws is dry, use raw umber to add some shadows to the bottom of the claws.

7. When everything is fully dry, use your white and black gel pens to address the smaller details, such as defining Hedwig's feathers and facial features. If you think that Hedwig may need more white in places, you can always use your white gel pen to add more where necessary.

Dobby the House-Elf

"Dobby has no master! Dobby is a free elf!"

—Dobby, *Harry Potter and the Deathly Hallows – Part 1*

COLORS

| LIGHT RAW UMBER | LIGHT ALIZARIN CRIMSON | LIGHT INDIAN RED | INDIAN RED | VANDYKE BROWN |

| DARK INDIAN RED | LIGHT PALE GREEN | SAP GREEN | DARK SAP GREEN |

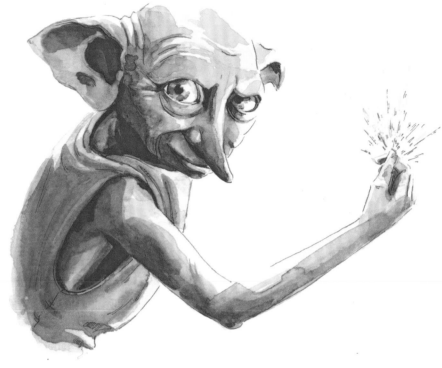

RECOMMENDED SUPPLIES

Size 02 round brush Black gel pen

Size 03 brush White gel pen

Size 01 brush

1. Dilute the raw umber with about 10 percent water to create light raw umber. Using your size 02 round brush, apply this light raw umber to the majority of Dobby's skin, leaving some white areas on the top right side of his face and arm to reflect light.

2. Next, add water to your size 03 brush and apply light alizarin crimson to Dobby's skin, continuing to preserve the white areas.

3. While that layer is still wet, dilute the Indian red with some water, and apply the light Indian red on Dobby's skin—primarily on the left side—preserving the lighter layer in various areas, to enhance facial features and reflected light. While this layer is still wet, use your size 02 brush to add some Indian red to the darker areas of Dobby's skin, and let the watercolors blend.

4. When that layer is completely dry, use your size 01 brush to add some dark Indian red to the darkest areas of Dobby's skin, particularly on his inner ears, under his nose, under his arm, and around his neck. If you need to smooth out any transitions, take a clean, wet brush and rub it between the two colors. Let the skin dry first and then use your fine brush to add some details on the skin, such as the wrinkles under his eyes, his eyelid shadows, his cheekbone lines, etc.

5. When Dobby's skin is fully dry, create a light pale green by mixing 90 percent sap green with 10 percent Vandyke brown, and then add water to that color paint his eyes and his shirt. Then apply sap green to the inner parts of his eye to create a three-dimensional look.

6. Now it's time to add shading to Dobby's shirt. Apply sap green to almost all of Dobby's shirt, leaving some areas lighter (as seen in the example illustration). While this layer is still wet, apply dark sap green where you see the darker shades of green in the example. Avoid using too much paint on your brush. Also, it's best to use the wet-on-wet technique (page 12) here to help the color blend together nicely.

7. When his shirt is dry, use your size 01 brush to add more dark sap green where there are more shadows and wrinkles. Use a clean, wet brush to smooth the transition between the shades of green on his shirt to create a fabric texture. The fabric of this kind of shirt doesn't reflect light well, so it's important to smooth the transition between the colors. Then, add any remaining shadows with dark sap green.

8. Use your black gel pen to color in the pupils and to add some dark lines where necessary, such as around Dobby's eyelids, under his chin, under his nose, and where the shirt and his arm cast shadows. Don't forget to add some brightness to his eyes with the white gel pen, too.

Aragog the Acromantula

"Farewell, Aragog, king of arachnids, whose long and faithful friendship those who knew you won't forget!"

—Horace Slughorn, *Harry Potter and the Half-Blood Prince*

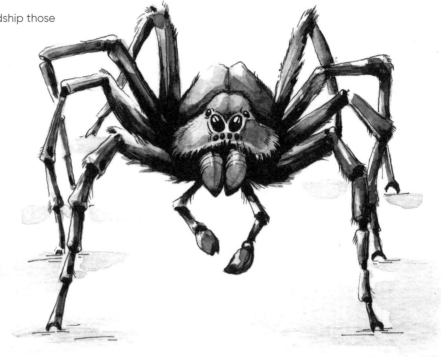

COLORS

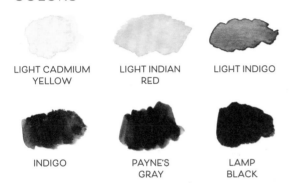

LIGHT CADMIUM YELLOW

LIGHT INDIAN RED

LIGHT INDIGO

INDIGO

PAYNE'S GRAY

LAMP BLACK

RECOMMENDED SUPPLIES

Size 02 round brush **Black gel pen**

Size 000 brush

1. Using your size 02 round brush, apply light cadmium yellow to almost all of Aragog's body, leaving some white areas on the upper left sides to indicate the light source.

2. Then, take some light Indian red (Indian red with 95 percent water) and apply it to a few areas—mainly on his skull and, joints and around his eyes—while the first layer of paint is still wet so there will be a smooth transition between the colors.

3. Take some light indigo and apply this color where the shadows are the most prevalent. Avoid painting this color where the light is the strongest.

4. When all areas are completely dry, apply indigo to accent any shadows, especially between Aragog's legs and body. If the transitions between the colors are too sharp, use a clean, wet brush to blend the colors and smooth the transitions.

5. Now, use Payne's gray between the areas where each of the leg segments connect to create a three-dimensional look to the legs.

6. Add some lamp black to the darkest areas of Aragog to indicate where the shadows are. While painting with this color, be sure to create the furry texture around Aragog's face. To do this, apply a very small amount of paint on your size 000 brush and tilt it in your hand to make it easier to control. Then, place your brush under Aragog's head where you see the lamp black begin. Move your brush down, increasing the pressure you apply to the brush and reducing the tilt as you paint.

7. Add any final details with a black gel pen, such as in the bristles around Aragog's legs, the lines around his eyes, and any other border lines where necessary.

DIFFICULTY: ⚡⚡

Pickett the Bowtruckle

"See, I wouldn't have let them keep you, Pickett. Pick, I would rather chop off my hand than get rid of you . . . After everything you have done for me—now come on."

—Newt Scamander, *Fantastic Beasts and Where to Find Them*

COLORS

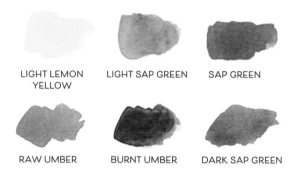

| LIGHT LEMON YELLOW | LIGHT SAP GREEN | SAP GREEN |

| RAW UMBER | BURNT UMBER | DARK SAP GREEN |

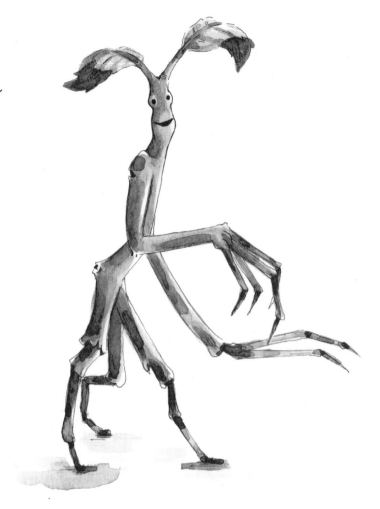

RECOMMENDED SUPPLIES

Size 02 round brush

Black gel pen

1. Using a size 02 round brush, paint the entire Pickett sketch with light lemon. Make sure to leave some white areas, especially on the right side of the body, to indicate light reflection.

2. Apply light sap green (sap green mixed with about 90 percent water) while the first layer is still wet. Paint Pickett's toes and hands with that color as well. Make sure that the green is blending smoothly with the yellow before it dries.

3. When Pickett's body is completely dry, start painting him with sap green—you will be using the same color for most of Pickett's body. Avoid painting the entire body, leaving some lighter parts to illustrate the light reflection. And don't forget to add a few line details on the leaves at the top, too.

4. Next, add a very small amount of lamp black to sap green to create dark sap green and use it to paint the darker parts, such as the left side of the figure and under his leaves. The entire body should look smooth, so be sure to use a clean, wet brush to soften any transitions between colors, if necessary.

5. Use raw umber to paint Pickett's fingers. Avoid painting the fingers evenly, and leave some green areas to capture a more natural, organic feel.

6. While the raw umber is still wet, add some burnt umber to the woodier parts of Pickett to give him dimension.

7. Finally, use a black gel pen to darken the eyes, lips, and any other details.

Mimbulus Mimbletonia

"It's really, really rare . . . I don't know if there's one in the greenhouse at Hogwarts, even. I can't wait to show it to Professor Sprout. My great uncle Algie got it for me in Assyria. I'm going to see if I can breed from it."

—Neville Longbottom, *Harry Potter and the Order of the Phoenix*

COLORS

LIGHT CADMIUM YELLOW	SAP GREEN	DARK SAP GREEN	YELLOW OCHRE

RAW UMBER	BURNT UMBER	HOOKER'S GREEN	INDIAN RED

RECOMMENDED SUPPLIES

Size 02 round brush White gel pen

Size 02 brush Black gel pen

Size 01 round brush

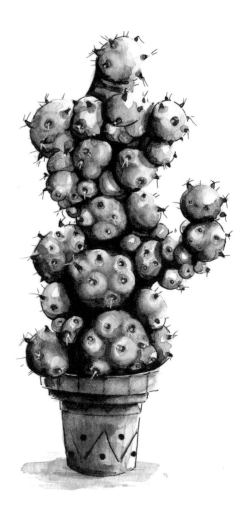

1. Use your size 02 round brush to paint light cadmium yellow on the entire plant, except for any white areas you see (like on the top right corner of the plant bulbs). The overall plant is like a sculpture, with each bulb an individual piece. So, think of each section as a single piece and paint to define the geometric shapes. The light source is located at the top right side of the page. Leave some white areas in that direction to indicate the light source and apply light cadmium yellow to the entire plant.

2. While the first layer is still wet, apply sap green to the bottom left part of each bulb. Here, you can use the wet-on-wet technique: Gently touch the tip of your brush to the paper with sap green, leaving a very small amount of paint on the paper. Let the water carry this color to the entire area of the bulb. Repeat this technique on the rest of the plant. If needed, use a clean brush to carry the sap green around the body of the plant to create the round shape of the bulbs. If you feel like the sap green is too saturated, use a clean tissue or a clean, dry brush to suck up any unwanted paint from those areas.

3. Next, apply a small amount of black to the sap green to create a slightly darker shade—dark sap green—and use your brush to apply this color to the bottom left side of the entire plant. After this step, you should have a general shape of the plant. If any

darker shades are flowing into the areas that are supposed to be lighter, use a clean piece of tissue to stop the colors from blending.

4. Use a size 02 brush to apply yellow ochre as the base color of the pot. While the base is still wet, apply raw umber to the pot and blend the two colors together.

5. After the base color is dry, use burnt umber to add shadows on the pot.

6. Then, use a size 01 round brush and paint Hooker's green under the plant bulbs, as well as between them, to finalize the shape. Feel free to use a clean brush to blend between colors if the transitions are not smooth enough.

7. After everything is dry, use Indian red to add the reddish flowers on the plant. Keep them small and wait for them to fully dry before the next step. Then, grab a clean size 01 brush, dip it in clean water, and use it to rub one side of the red flowers to fade them into the plant's surface and give them a conical shape.

8. Finally, use your white gel pen to add the thorns and light reflections on the plant where necessary. Use your black gel pen to outline the plant, add some more thorns, or apply any decorative details to the pot.

Arnold the Pygmy Puff

Luna Lovegood: [about Ginny's pygmy puff] "He's lovely!
They've been known to sing on Boxing Day, you know. Quibbler?"

Ginny Weasley: "Oh please. What's a Wrackspurt?"

Luna Lovegood: "They're invisible creatures.
They float in your ears and make your brain go fuzzy."

—*Harry Potter and the Half-Blood Prince*

COLORS

LIGHT RAW SIENNA LIGHT RAW UMBER LIGHT PERMANENT ROSE

PERMANENT ROSE LIGHT DIOXAZINE PURPLE LAMP BLACK

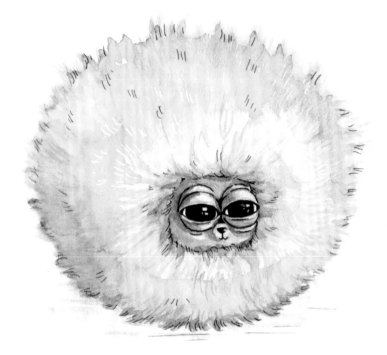

RECOMMENDED SUPPLIES

Size 02 round brush	6mm flat wash brush	Black gel pen
Size 01 round brush	Size 000 brush	White gel pen
Size 03 round brush		

1. Using your size 02 round brush, paint Arnold's face with light raw sienna, while leaving some white areas to indicate where the light is being cast. To create some of the lighter colors on the palette, mix 10 percent of that color with about 90 percent water.

2. When this layer is dry, use light raw umber to add shading to Arnold's skin. Use a size 01 round brush to give the eyes a round shape by adding shadows around the eyes.

3. Next, use a size 03 round brush to apply light permanent rose to the furry body, leaving some white gaps on the top right of his puff and around his face. To create light permanent rose, dilute about 5 percent of permanent rose with about 5 percent water. This will create a very light version of the color.

4. While the previous layer is still wet, use the same brush to apply permanent rose to create a watercolor effect between the two shades. Add a small amount of paint to your size 03 round brush and gently touch the lower left part of the body with the brush tip multiple times to release the paint, letting it fade with water. Apply the same technique where you see the darker shades of permanent rose. This will help you create a rounder, more dimensional shape. Now, do the same thing to the outer edges of his fur, as well as around the outside of the face.

5. While the paint is still partially wet, use a 6mm flat wash brush to add texture to the fur. Make sure that your brush is clean and dry, and then use the tip of the brush to paint without putting any pressure on it. Swipe it very, very gently over the wet areas to help your flat wash brush carry away the wet paint. This will help you blend the border of the Pygmy Puff's body to blur the outline, which will create a fluffy fur effect.

6. Use your size 000 round brush to apply light dioxazine purple to the fur to indicate the texture. Apply light dioxazine purple where the fur appears the darkest, like around the face and the bottom left of the body.

7. Use lamp black to fill in the pupils and the nose. Don't forget to leave some white areas on the outside and inside of the pupils for reflections.

8. Next, use a black gel pen to indicate the details around the eyes, eyelids, and nose. Try not to use the black gel pen too much on the fur, as that can cause a stiff, textured look, instead of a soft, furry look.

9. Finally, use your white gel pen to add textures to the fur.

Fang the Boarhound

"There's nothin' that lives in the forest that'll hurt yeh if yer with me or Fang."

— Rubeus Hagrid, *Harry Potter and the Sorcerer's Stone*

COLORS

LIGHT GRAY

LIGHT ALIZARIN CRIMSON

DARK GRAY

IVORY BLACK

LAMP BLACK

LIGHT SAP GREEN

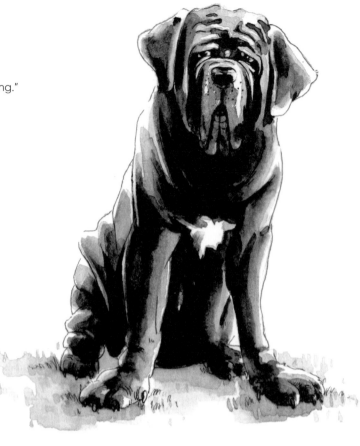

RECOMMENDED SUPPLIES

Size 03 round brush

Size 02 brush

Size 01 brush

Size 000 brush

White gel pen

Black gel pen

1. Using a size 03 round brush, apply light gray (gray with 80 percent water) to most of Fang's body. His dark fur reflects the light differently than lighter-colored creatures, creating a sharp contrast between the light and dark shadows.

2. While that layer is still wet, apply light alizarin crimson around Fang's mouth and nose, which will add a touch of color to help him look more alive. Then, add some light alizarin crimson on Fang's legs and paws, but be careful not to overdo it.

3. Use the same brush you've used so far to apply dark gray (gray with 20 percent ivory black). After you dip your brush into the color, start painting from where the darkest shades are first. Then, as you move your brush around, the amount of paint will lessen, and the shade of the color will lighten, giving you more control over the transitions between shades.

4. Now, use a size 02 brush to add some ivory black to the darkest areas on Fang's body. When you are done painting the general shades, take your size 01 brush and paint the details around his face. Be careful of where you paint, and tilt your brush about 80 degrees to paint the lines around his eyes. Then, paint ivory black on his ears and face wrinkles. Use a clean, wet brush on those black lines to create a smoother transition between shades, especially on his ears and forehead.

5. When the paint is dry, use lamp black to add the darker shades to his belly, the left side of each front leg, and his nose. Then paint his forehead wrinkles and the folded skin around his cheeks. Use a size 000 brush where the lines are thinner to ensure better control over your paint.

6. Next, apply light sap green to the ground around Fang to create a grassy-looking environment.

7. Use a white gel pen to add any reflections or white areas, if necessary.

8. Finally, use a black gel pen to indicate Fang's unique eye and mouth shapes. After that, add any additional details to Fang's body and the grass.

Trevor the Toad

"Has anyone seen a toad? A boy named Neville's lost one."

—Hermione Granger, *Harry Potter and the Sorcerer's Stone*

COLORS

LIGHT RAW
UMBER

RAW UMBER

VANDYKE
BROWN

LIGHT SAP
GREEN

LEMON YELLOW

LAMP BLACK

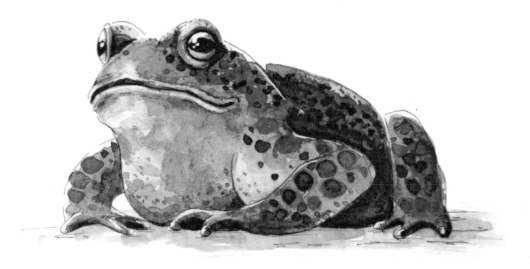

RECOMMENDED SUPPLIES

Size 03 round brush White gel pen

Size 02 round brush Black gel pen

1. Use a size 03 round brush to apply light raw umber as the base color of Trevor's body. Apply it everywhere except for the whites of the eyes, and leave some white areas where necessary to indicate the light source.

2. While the first layer is still wet, apply raw umber, allowing the color to move with the water to create the uneven skin texture that toads typically have.

3. When all the paint is dry, continue to apply raw umber with the tip of your round brush to create dots on Trevor's skin. Create the larger dots where the color is the strongest and the smaller dots where the color begins to fade.

4. Then, use your size 03 round brush to add the toadlike texture with Vandyke brown in the darkest areas. The upper part of Trevor's body is the lightest, so make sure to use this color on his lower body. Apply the paint with your brush in large, circular shapes where it is darker to indicate Trevor's texture.

5. Now, use Vandyke brown to give his body some shadows. When everything is dry, use your size 02 round brush with a medium amount of paint. Try not to rub your brush on the same area too many times, as that can fade the texture you added in the previous step.

6. Then, paint Trevor's eyes with light sap green. If you'd like, add a touch of lemon yellow in the sap green to make the eyes shine. Then, use lamp black to paint Trevor's pupils.

7. Finally, use your white gel pen to add some separation between the individual body parts. Use your black gel pen to add any final details.

McGonagall as a Cat

"Perhaps it would be more useful if I were to transfigure Mr. Potter and yourself into a pocket watch?"

—Professor McGonagall, *Harry Potter and the Sorcerer's Stone*

COLORS

LIGHT RAW SIENNA YELLOW OCHRE LIGHT ALIZARIN CRIMSON LIGHT SAP GREEN

BURNT UMBER IVORY BLACK LIGHT RED INDIGO

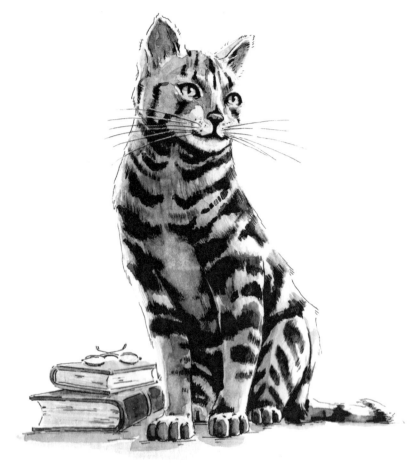

RECOMMENDED SUPPLIES

Size 04 round brush

Size 02 brush

Size 01 brush

6mm flat wash brush

Size 03 brush

White gel pen

Black gel pen

1. Using a size 04 round brush, apply light raw sienna to most of the cat's entire body, leaving some of the outer areas white to reflect the light source. Use the same color to paint the pages of the books next to the cat.

2. When the first layer is dry, use a size 02 brush to apply yellow ochre to the left side of the cat as its base color. Leave the right side alone for now, as well as the lighter edge along the left side of the cat. This color should appear only on the left/middle part of the cat.

3. Using a size 01 brush, fill in the cat's inner ears and nose with light alizarin crimson and then paint her eyes with light sap green. Try to avoid filling in the eyes entirely to include a variety of green shades, making it more realistic.

4. Use your size 02 round brush to apply burnt umber, casting the necessary shadows on the cat's body. First, start by applying the color to the larger areas, such as the cat's stomach and on the inner sides of its legs. Then, take your size 01 brush and apply detailed shadows around the face.

5. While that layer is still wet, take a clean, dry 6mm flat wash brush and use it to smudge the paint to create a blurring effect on the cat's body in the direction of the fur.

6. When you are happy with the general shape of the cat, wait for it to fully dry, then take your size 02 brush and begin painting the cat's stripes. The stripes are mostly asymmetrical, so be careful where you are painting. First, mix ivory black with about 80 percent water. Using this half-transparent black, paint the black marks on the cat's back. Because more light is on the back, it should be slightly lighter than other parts. Then, use pure black to place the other marks on the cat, which appear much darker, such as the marks on the cat's stomach, inner legs, neck, and face.

7. After you paint the cat's markings, take a clean size 03 brush, dip it in clean water, and rub the extra water between the black and the other colors where it needs to be less sharp. Smooth any transitions with this technique, but avoid overdoing it, which could create a muddy look. Then, take your size 01 brush and add some individual black furs to enhance the cat's furry texture.

8. While the cat is drying, paint the books with light red and indigo. I recommend diluting these colors with water so the image doesn't appear too saturated.

9. Finally, use your white and black gel pens to add any remaining details. Pay close attention to the dark border around the cat's eyes.

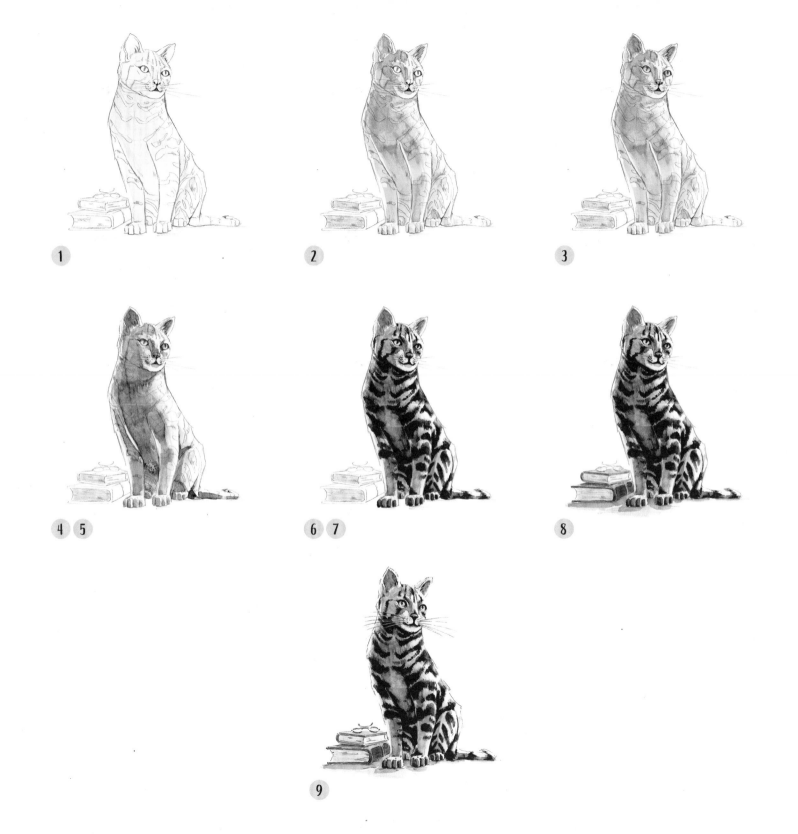

DIFFICULTY: ⚡⚡

Dirigible Plum Tree

"Keep off the Dirigible plums."

—Ron Weasley, *Harry Potter and the Deathly Hallows — Part 1*

COLORS

LIGHT RAW UMBER BURNT UMBER LIGHT SAP GREEN

HOOKER'S GREEN VANDYKE BROWN CADMIUM ORANGE

RECOMMENDED SUPPLIES

Size 03 round brush Size 000 brush

Size 01 round brush White gel pen

Size 02 brush Black gel pen

Size 01 brush

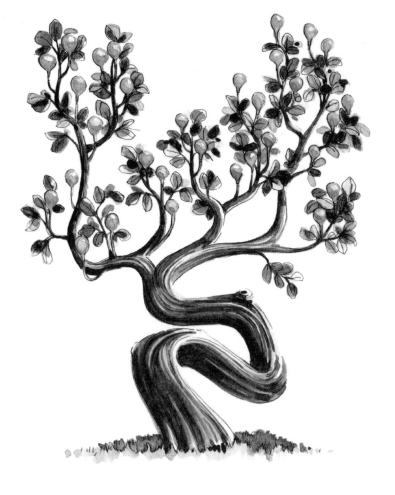

1. Using your size 03 round brush, paint the bark of the plum tree with light raw umber. Try to leave some white areas to indicate the light source, which is located on the top right of the tree in the example illustration.

2. When the previous layer is completely dry, use a size 01 round brush to apply burnt umber to the bark of the tree. Pay close attention to the curves of the tree branches from the example illustration, and paint in that direction. Use a clean, wet brush to slightly fade this color into the previous one.

3. While the body of the plant dries, begin painting the leaves with light sap green. Apply a small amount of paint to your size 02 brush and paint the leaves using the tip of your brush.

4. Then, use your size 01 brush and add a pinch of Hooker's green to the tip. Paint the leaves while the light sap green layer is still wet to ensure that the two colors will fade into each other.

5. When everything is dry, use your size 02 brush to add some water to the Hooker's green on your palette to make it more transparent. Use this color to add some semitransparent leaves behind the main ones to create a stronger sense of depth. Add the leaves by touching the paper lightly with the tip of your paintbrush.

6. Then, use your size 02 brush to add Vandyke brown to the darkest parts of the body of the plant. It's best to add it to the largest darker areas first and then use a thinner brush to fill in the details. I suggest using a size 000 brush for the thinner parts of the branches.

7. Use your size 01 brush to add cadmium orange to the plums. With the tip of your brush, place a very small amount of cadmium orange to the tops of the plums and then take a clean, wet brush and pull the color downward slightly toward the bottom of the plums. Try to avoid having too much water on your brush, which makes the color harder to control, and make sure to have a clean tissue nearby, just in case the orange overflows.

8. Finally, use your gel pens to add any details, especially to the leaves and base of the tree.

Whomping Willow

"Do you have any idea how serious this is? You've risked the exposure of our world. Not to mention the damage you inflicted on a Whomping Willow that's been on these grounds since before you were born."

—Severus Snape, *Harry Potter and the Chamber of Secrets*

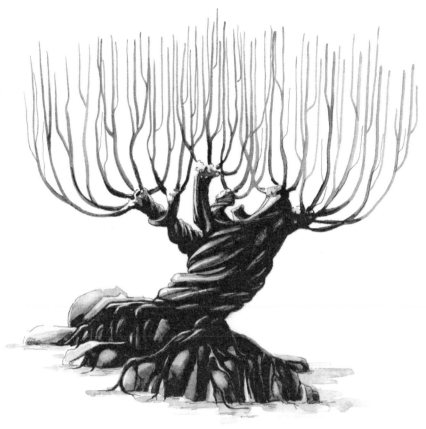

COLORS

LIGHT YELLOW OCHRE RAW UMBER VANDYKE BROWN

PALE GREEN IVORY BLACK

RECOMMENDED SUPPLIES

Size 03 round brush	Size 000 brush
Size 02 brush	White gel pen
Size 01 brush	Black gel pen

1. Using a size 03 round brush, paint the body of the Whomping Willow with light yellow ochre. Leave a few white areas on the left side of the body for light reflection. Use your size 02 brush to add a layer of raw umber to the trunk of the tree without waiting for the previous layer to dry. Just make sure to leave some lighter areas for light reflection.

2. When the previous layer is fully dry, use a size 02 brush to apply Vandyke brown to the body of the tree. This layer will indicate the twists in the tree trunk. Tilt your brush and use your wrist to lead your hand, and follow the lines on the trunk while painting. Then, tilt your brush upward slowly to create a line that decreases in thickness as you paint.

3. Use a clean, wet size 01 brush to smooth the Vandyke brown. To create the contrast in the trunk while maintaining a dimensional look, try to keep the white gaps clean while smoothing the Vandyke brown into the lighter colors. Slightly wet your brush and rub it where the Vandyke brown and white areas touch, just to smooth the edges a bit.

4. When the trunk is dry, start painting the rocks. Use a size 02 brush to apply the pale green to almost the entire rocky area.

5. While the rocky area is still wet, paint some raw umber on top of this layer. This color doesn't need to be seen clearly, but it will help create a more organic, natural look. Then, use Vandyke brown on the darkest parts of the stones. Some of these stones are less round and have sharper edges.

6. Use your size 000 brush to add the thin branches with Vandyke brown. Try to avoid having too much paint on your brush during this step. Start with your brush tilted and slowly straighten it as you get closer to the end of branches to create a thinner end to each branch.

7. Use your size 01 brush to add some ivory black where you see the darkest parts of the plant, such as under the roots, between the rocks, and on the right side of the tree.

8. Finally, use a white gel pen, if necessary, for more brightness on your tree, and use a black gel pen to add any final details.

Mandrake

"Mandrake or Mandragora is used to return those who have been petrified to their original state. It's also quite dangerous. The Mandrake's cry is fatal to anyone who hears it."

—Hermione Granger, *Harry Potter and the Chamber of Secrets*

COLORS

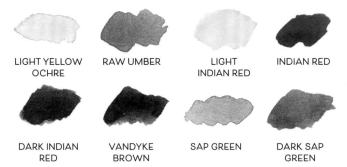

LIGHT YELLOW OCHRE	RAW UMBER	LIGHT INDIAN RED	INDIAN RED
DARK INDIAN RED	VANDYKE BROWN	SAP GREEN	DARK SAP GREEN

RECOMMENDED SUPPLIES

Size 02 round brush Size 01 brush

Size 03 brush Black gel pen

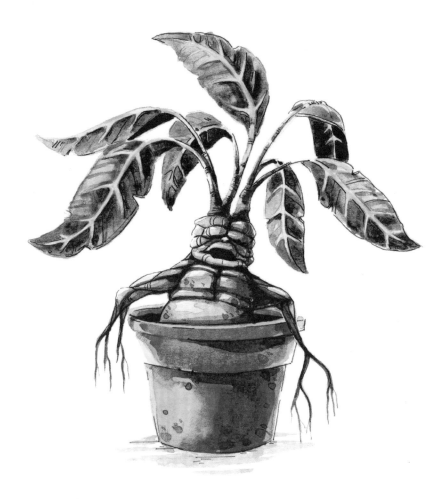

1. Using your size 02 round brush, paint the entire body of the Mandrake, including the leaves, with light yellow ochre. Don't forget to leave some white areas for light reflection.

2. While the first layer is still wet, start applying raw umber. Be careful around the face and avoid coloring the lighter parts, as shown in the illustration. Use a clean tissue to control the paint, if needed.

3. While everything is drying, use your size 03 brush to apply light Indian red (mix about 80 percent water with Indian red) to the pot the Mandrake is in.

4. While this layer is still wet, apply Indian red to the right side of the pot.

5. Let the pot fully dry and then add dark Indian red (Indian red with 10 percent lamp black) where you can see the darkest parts of the pot in the example. Use the tip of your brush to add a few dots to give the pot some texture and imperfections.

6. Then, use your size 01 brush to add Vandyke brown to the darker parts of the Mandrake's body. Be careful around the face and smooth the transitions with a clean wet brush, if needed.

7. Now it's time to paint the leaves. Use your size 03 brush and paint them with sap green. Leave some lighter areas to indicate reflected light.

8. While the previous layer is still wet, apply dark sap green (sap green with about 20 percent lamp black) to the leaves by painting small touches with the tip of your brush where you see the darker shade of green, such as under the leaves, as well as the tips and roots of the leaves. Let the water carry the color away to create a watercolor effect.

9. When the leaves are fully dry, use your size 01 brush to add dark sap green under the leaves and around the Mandrake's veins to indicate its structure.

10. Finally, use your black gel pen to add any remaining details on the leaves and face. Add some curved vertical lines to indicate the Mandrake's shape, too.

Fluffy the Three-Headed Dog

"...he's mine—bought him off a Greek chappie I met in the pub las' year—I lent him to Dumbledore..."

—Rubeus Hagrid, *Harry Potter and the Sorcerer's Stone*

COLORS

YELLOW OCHRE

LIGHT RAW UMBER

RAW UMBER

BURNT UMBER

VANDYKE BROWN

IVORY BLACK

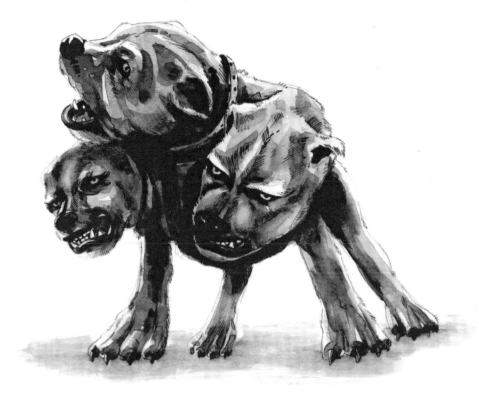

RECOMMENDED SUPPLIES

Size 03 round brush	Black gel pen
Size 02 round brush	White gel pen
6mm flat wash brush	

1. Using a size 03 round brush, apply yellow ochre to almost all of Fluffy's body, while leaving some white gaps to reflect the light. Don't forget to paint his eyes with yellow ochre, too.

2. This is a complicated design to paint, so go through the steps slowly and carefully. Add the shading slowly to avoid mistakes. Take some light raw umber and apply it where the shadows cast the most, on the lower left side of Fluffy. This layer will partly disappear under subsequent layers, so use this step to define Fluffy's shapes more fully.

3. Next, take some raw umber and add color to Fluffy's fur. You do not need to wait for the previous layer to dry, because the blending colors create a better transition between the shades.

4. Using a size 02 round brush, apply burnt umber where the shadows are the strongest, such as around Fluffy's eyes and on his nose, under his necks, and on his body.

5. Now add Fluffy's fur texture. With your 6mm flat wash brush, add some texture where the burnt umber is still partly wet. Using a clean, dry brush, very lightly carry the wet paint around the paper. Make sure to always paint in the direction of his fur.

6. To add the final color to Fluffy, use your size 03 round brush and apply Vandyke brown carefully on the darkest areas. Study Fluffy's face carefully to avoid misplaced shadows, as these can create anatomical mistakes. Use the flat wash brush again to create some fur texture if necessary.

7. Using your size 02 brush, apply ivory black to paint the bottom of each one of Fluffy's noses to differentiate them from the heads with darker shadows.

8. Finally, it's time to use a black gel pen to apply any final details, such as creating lines to illustrate Fluffy's fur. Be careful about the direction you paint the fur, and be sure your lines indicate those directions.

9. Use a white gel pen to add light in the eyes, teeth, and anywhere the light reflects the most, if necessary.

Grindylow

"Fleur never got past 'ze Grindylows!"

—Hermione Granger, *Harry Potter and the Goblet of Fire*

COLORS

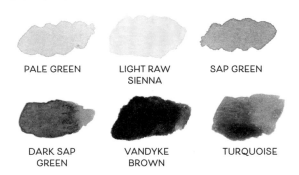

PALE GREEN LIGHT RAW SIENNA SAP GREEN

DARK SAP GREEN VANDYKE BROWN TURQUOISE

RECOMMENDED SUPPLIES

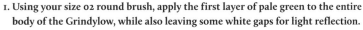

Size 02 round brush Black gel pen

Size 01 brush White gel pen

1. Using your size 02 round brush, apply the first layer of pale green to the entire body of the Grindylow, while also leaving some white gaps for light reflection.

2. Paint the tentacles with light raw sienna (raw sienna with about 80 percent water) and apply a small amount of that color to the head and body to balance the overall color.

3. Apply sap green to the Grindylow's entire body while the light layer is still partly wet. Don't forget to leave some pale green areas to create a three-dimensional look for the round body, head, and arms.

4. Add some black paint to sap green to create a darker version of this color (dark sap green) to use where the shadows appear the most. While applying this shade on the Grindylow's face, use a size 01 (or thinner) brush to paint the Grindylow's eyes, under the neck, and on the left side of the body. Also add some highlights to the tentacles to indicate their shapes. Save the details on the mouth for the gel pen (step 7).

5. When you are satisfied with the shadows on the Grindylow, move on to painting the tentacles. Use Vandyke brown to create shadows and small details. Leave the suction cups a bit lighter and paint the darkest shades of brown on the interior parts of the tentacles. Use a less diluted brown on the areas closer to the body and dilute it with more water where the Vandyke brown shade is slightly lighter.

6. Next, paint the Grindylow's eyes with turquoise.

7. Finally, use a white gel pen to add reflections in the Grindylow's eyes and to help define its teeth. Use your black gel pen to fill in the space in the inner mouth and to add any additional details. Use a white gel pen to highlight the eyes and suction cups, too.

DIFFICULTY: ⚡⚡⚡

Werewolf

"Not at all up to your usual standard, Hermione. Only one out of three, I'm afraid. I have not been helping Sirius get into the castle, and I certainly don't want Harry dead. But I won't deny that I am a werewolf."

—Remus Lupin, *Harry Potter and the Prisoner of Azkaban*

COLORS

LIGHT GRAY

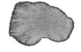

LIGHT INDIGO

INDIGO

IVORY BLACK

LEMON YELLOW

RECOMMENDED SUPPLIES

Size 03 round brush **White gel pen**

Black gel pen

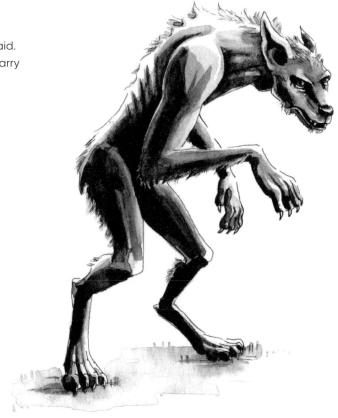

1. Use your size 03 round brush to apply light gray to define the general shape of the werewolf's body. Make sure to leave big white gaps to illustrate the moonlight shining upon the character.

2. Wait for the first layer to dry completely and then apply light indigo to the werewolf's body to define the anatomy. Paint everywhere except for the white and light gray areas in the example illustration. Remember, you will be filling in the details of the anatomy of the werewolf, so be mindful of where you are painting. Use a clean, wet brush to smooth out any transitions between the two shades.

3. When all areas are dry, apply indigo where the shadows are the strongest, such as on the eyelids, behind the nose, on the inner body, and behind the legs.

4. Then apply ivory black to create stronger shadows where necessary. If you make any mistakes while painting, don't worry, as you can use a clean tissue to soak up the paint you've applied and rub the area gently with a clean brush to peel off the paint.

5. After adding lemon yellow to the werewolf's eyes, start adding in the details with your gel pens. Use your white gel pen to add light reflections in the eyes and any necessary reflections around the face and body. Then, use your black gel pen to add some lines that border the face and any remaining details.

Norbert the Dragon

"I've decided to call him Norbert. He really knows me now, watch. Norbert! Norbert! Where's Mummy?"

—Rubeus Hagrid, *Harry Potter and the Sorcerer's Stone*

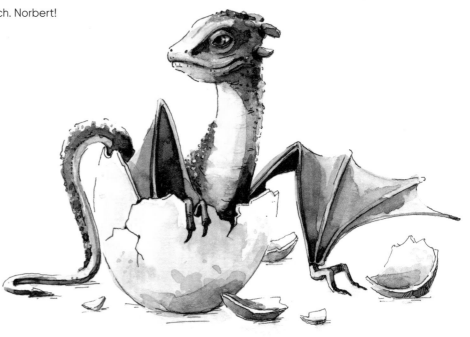

COLORS

LIGHT RAW SIENNA	LIGHT RAW UMBER	RAW UMBER	CADMIUM ORANGE

LIGHT SAP GREEN	BURNT UMBER	VANDYKE BROWN

RECOMMENDED SUPPLIES

Size 02 round brush	White gel pen
Size 01 round brush	Black gel pen
Size 03 round brush	

1. Use your size 02 round brush to apply light raw sienna to the entire image, including the eggshells. Don't forget to leave some parts white, especially where the light reflects in the example image.

2. Then, add light raw umber to Norbert's body. This color will be the base color of his skin, so apply the light raw umber only to his body, and not to the wings or the eggshells.

3. Let the previous layers dry completely, and then apply raw umber to the right side of Norbert's face, neck, back, and tail. Use a clean brush to blend this color into the previous shades for a smoother transition.

4. Take your size 01 round brush and use the tip to apply cadmium orange to the top of Norbert's head, back, and tail. Apply this color as tiny dots to give his skin a bit of texture.

5. Use your size 03 round brush to apply light sap green to Norbert's wings and tail and the darker parts of his neck and face, creating a secondary color to indicate the light reflections on his skin.

6. While the first layer is still wet, add some burnt umber to Norbert's wings. Avoid using the same shade of paint everywhere, because after you apply multiple shades of the same color, it creates a richer, more realistic look. Use less water here to create a darker color where the shadows are the strongest and to lighten the color where the light is reflecting the most. Wait for the first layer to fully dry and then apply a second layer of burnt umber where the changes between shades are sharper, such as the inner and outer surfaces of his wings.

7. Carefully apply Vandyke brown to the parts of Norbert's body that are still in the eggshell.

8. Then, use light Vandyke brown to complete the eggshell. Using the tip of your brush, add some small dots, which will create an ancient texture on the eggshell.

9. Finally, use your white gel pen to add light reflections in his eye and to underline the white part of the eggshell. Use the black gel pen to add the smaller details in his eye and for his overall texture where necessary.

Mountain Troll

"I went looking for the troll because I—I thought I could deal with it on my own—you know, because I've read all about them."

—Hermione Granger, *Harry Potter and the Sorcerer's Stone*

COLORS

| LIGHT CADMIUM YELLOW | LIGHT INDIAN RED | LIGHT SAP GREEN | LIGHT INDIGO |

| INDIGO | RAW UMBER | INDIAN RED | VANDYKE BROWN |

RECOMMENDED SUPPLIES

Size 03 round brush White gel pen

Size 02 brush Black gel pen

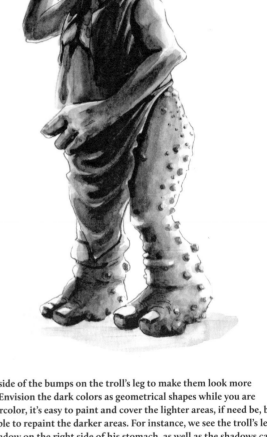

1. Use your size 03 round brush to apply light cadmium yellow to the troll's entire body, while still leaving some white areas to indicate the light source on the top right side of the paper.

2. Apply light Indian red while the previous layer is still wet. Avoid applying the color everywhere evenly to create more texture and overall contrast on the troll's skin.

3. Then, take your size 03 round brush and apply light sap green to the troll's body, but avoid using this color where the light reflects the most (like on the right side of the troll).

4. When the previous layers are fully dry, apply light indigo to begin adding shadows on the left side of the troll. Leave the clothing alone for the time being.

5. Using a size 02 (or thinner) brush, apply indigo to define the anatomy of the troll. There is a strong light source on his right side, so the darker colors/shadows should appear on his left side. Apply the indigo where the darkest shadows are located and then use a clean, wet brush to fade this color away. Skin doesn't create much contrast between shades, so if it doesn't look right, use a clean tissue to remove any extra water and paint and then use a clean, wet brush to rub between colors and smooth their transitions.

6. Paint the lower left side of the bumps on the troll's leg to make them look more three-dimensional. Envision the dark colors as geometrical shapes while you are painting. With watercolor, it's easy to paint and cover the lighter areas, if need be, but it's not always possible to repaint the darker areas. For instance, we see the troll's left arm casting a big shadow on the right side of his stomach, as well as the shadows cast by his clothing.

7. Next, paint the troll's clothing with raw umber. Avoid painting too evenly everywhere, and leave some lighter parts to indicate the wrinkles in his clothing. Apply Indian red while the first layer is still wet. Repeat these steps with his club.

8. When everything is dry, apply Vandyke brown where the shadows are the strongest.

9. Finally, use your white gel pen to add light reflections in the troll's eyes and anywhere that has a sharp reflection in the example illustration. Use your black gel pen to add the details on his face and body. Be very careful when lining his eyes and lips. Every tiny line makes a huge difference in his facial expression, so I recommend practicing this on a spare piece of paper first.

Nagini as a Snake

(To Nagini, speaking in Parseltongue)

"The boy has discovered our secret, Nagini. It makes us vulnerable. We must deploy all our forces now to find him. And you, my friend, must stay close."

—Voldemort, *Harry Potter and the Deathly Hallows – Part 2*

COLORS

LIGHT YELLOW OCHRE RAW UMBER YELLOW OCHRE SAP GREEN

VANDYKE BROWN LAMP BLACK CADMIUM ORANGE SEPIA

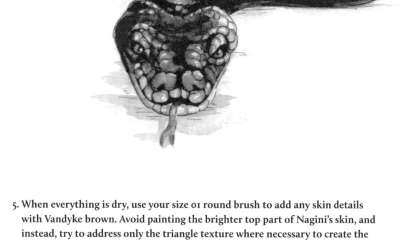

RECOMMENDED SUPPLIES

Size 03 round brush White gel pen

Size 02 round brush Black gel pen

Size 01 round brush

1. Using a size 03 round brush, apply light yellow ochre to Nagini's entire body, keeping white areas for light reflections where necessary. Typically, snakes have wet-looking skin, so those white areas will help create the right texture.

2. While the first layer is still wet, use your size 02 round brush to apply raw umber to the entire body of the snake, except where it appears white and yellow in the example. This will be the base color of Nagini's skin. Nagini has a round, shiny body, so always use darker shades on the opposite side of the light source and make sure the transitions between the colors are soft.

3. Use a size 02 round brush to apply yellow ochre to the upper part of Nagini's body while the skin is still wet. Add a small amount of paint to the tip of your brush so it will fade to create the round curve of her body. When all areas are dry, apply a small amount of yellow ochre with the tip of your brush and touch the paper very gently to create dots with the paint. This time, the color won't fade away, so make sure that you are following the triangle pattern of Nagini's body.

4. Then, add some sap green on the same parts of Nagini's body as in the previous step to include more variety in color. If you look closely, you will see the green paint beside the yellow ochre dots that you just added.

5. When everything is dry, use your size 01 round brush to add any skin details with Vandyke brown. Avoid painting the brighter top part of Nagini's skin, and instead, try to address only the triangle texture where necessary to create the pattern. Use the tip of your brush to create thin lines to indicate the bumpy skin, especially on Nagini's face. At the end of the tail, use fewer details and more faded colors to create a sense of depth and perspective.

6. When the paint is completely dry, use your size 02 round brush to apply a general shade of Vandyke brown to help you highlight Nagini's overall shape and make the texture look more realistic by naturally fading it away in some areas. Then, use a clean brush to fade between colors to create the bumpy texture on the face. Make sure to keep the right side of Nagini's face lighter to indicate the light source and create a more three-dimensional look.

7. Then, apply lamp black to the darkest parts of the overall snake.

8. Paint Nagini's eyes with cadmium orange and paint the tongue with sepia.

9. Finally, use your white and black gel pens to address any necessary light and fine details. Here, I used the black gel pen to create some additional texture on her skin and details on her face.

DIFFICULTY: ⚡⚡⚡

Griphook the Goblin

Griphook: "How did you come by this sword?"

Harry Potter: "It's complicated. Why did Bellatrix
Lestrange think it should be in her vault?"

Griphook: "It's complicated."

—Harry Potter and the Deathly Hallows — Part 2

COLORS

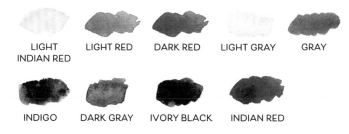

LIGHT
INDIAN RED LIGHT RED DARK RED LIGHT GRAY GRAY

INDIGO DARK GRAY IVORY BLACK INDIAN RED

RECOMMENDED SUPPLIES

Size 02 round brush **Black gel pen**

Size 01 brush **White gel pen**

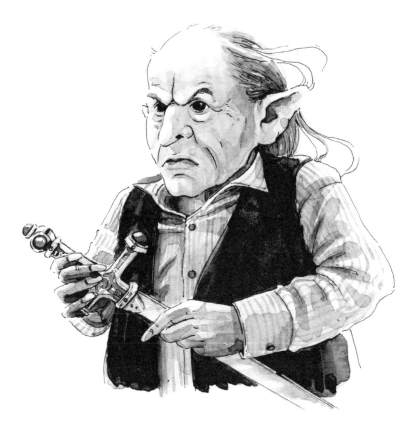

1. Start by painting the goblin's skin. Use a size 02 round brush to apply light Indian red (light red with about 90 percent water) to the goblin's skin, while leaving white areas for light reflection, as shown in the example.

2. Before the first layer dries, immediately apply light red where the shadows are the strongest on the goblin's skin. Use a clean brush to blend those two shades for a smoother transition and a more natural look. Then, use a clean tissue to absorb any extra paint if necessary.

3. Add a small amount of black to your light red to create dark red. About 85 percent light red and 15 percent black will do the trick. Always use a decent amount of water while you are blending your paint, as the more water you add, the more transparent your color will become, which allows you to see the previous layer on the paper.

4. When everything is dry, take a size 01 brush and use the dark red to paint the darkest parts of the goblin's skin, such as the inner ear, the neck, the palm, and on his lips.

5. After all areas are dry, you can begin painting the rest of the goblin. Using your size 02 round brush, apply light gray as the base color of the goblin's shirt and on the sword. On both objects, keep in mind where you need to leave white areas to create light reflections.

6. When the shirt is dry, apply gray where there is less light and where the wrinkles appear the most. Repeat this step for the sword and for the goblin's hair.

7. Then, use a clean brush to soften the color transitions on his shirt to create a smooth fabric texture. Avoid softening the transitions on the sword, as its material requires a sharper contrast in order to create a shiny, metallic look.

8. Use a size 01 brush to paint the stripes on the goblin's shirt with indigo, following the folds of the fabric to create a three-dimensional look. When the paint is dry, use the same color to add some darker shades to his shirt.

9. Apply dark gray (gray with about 20 percent of ivory black) to the goblin's hair and to his entire vest.

10. While the paint is still wet, apply the ivory black to his vest, leaving some parts slightly lighter to cast light. Use the same color on his hair to enhance the shadows. While you are waiting for the vest to dry, use ivory black on the darker parts of the sword as soon as the previous color is fully dry.

11. Paint the stones on the sword with Indian red. There are a few white parts on the stones that cast light reflection, so try to avoid painting those. Use your white gel pen to add those reflections afterward if needed.

12. Finally, carefully use your black gel pen to add the distinctive lines to the goblin's face. Add any additional final details to the design with both the white and black gel pens.

Venomous Tentacula

"... be careful of the Venomous Tentacula—it's teething."

—Professor Sprout, *Harry Potter and the Chamber of Secrets*

COLORS

SAP GREEN VIRIDIAN DARK VIRIDIAN LIGHT RAW UMBER RAW UMBER

VANDYKE BROWN LIGHT ALIZARIN CRIMSON INDIAN RED DARK INDIAN RED

RECOMMENDED SUPPLIES

Size 01 round brush White gel pen

Size 02 round brush Black gel pen

Size 000 brush

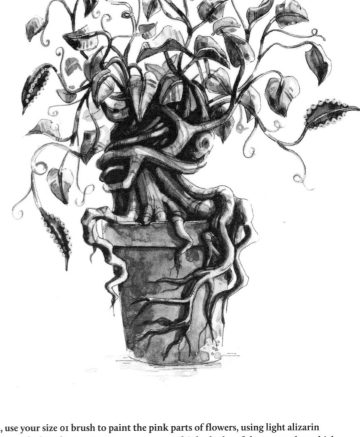

1. Use your size 01 round brush to start painting the leaves with sap green. Try not to paint everywhere, leaving some areas without color for light reflection.

2. Take a clean, wet brush while the sap green is still wet and blend the color around the leaves to create multiple shades of green on the surface of the leaves.

3. Use your size 01 round brush to apply viridian to the plant stalks. Tilt your brush and paint by moving your hand from your wrist to avoid shaky lines. Don't forget to add some lines to the leaves to give them a more interesting texture. You can also use a clean brush to fade these two greens into one another so they blend more evenly.

4. Add a bit of black in the viridian green to create dark viridian, and use it only on the darkest part of the leaves, where they connect with the trunk.

5. Then, use your size 02 round brush to paint the plant with light raw umber. Use this color to paint almost the entire plant, leaving a few white areas on the upper right parts of the trunk where the light source is located.

6. While the previous layer is still wet, apply raw umber and let the colors fade into one another.

7. When everything is dry, use your size 01 brush to add Vandyke brown to the trunk. Apply this color where the shadows are the darkest.

8. Then, use your size 01 brush to paint the pink parts of flowers, using light alizarin crimson and a lot of water. Here, you can see multiple shades of the same color, which depends on the amount of water you use to mix your color. First, I suggest using a generous amount of water in your mixture, and paint this color on the seeds of the plant. Then use a less water-diluted version of the color to add little shadows to the bottom left parts of the flowers to indicate their round shapes. When this color is dry, use your white gel pen to add any final reflections to the flowers.

9. Start painting the pot with Indian red, using your size 02 round brush on the larger surfaces and a size 000 brush where details are needed, such as around the roots. Use various shades of this color on the pot to give it more dimension; use less water to make it darker and more water to make it lighter.

10. When the pot is completely dry, use dark Indian red (Indian red mixed with a little black) to add any necessary shadows to the pot—primarily the shadows cast by the roots on the pot—so it creates a more realistic look.

11. If the roots and leaves still need more shadows, dilute black with some water and apply it as an extra layer where necessary.

12. Finally, use your gel pens to address the fine details, especially focusing on the thinner parts of the roots.

Zouwu

"She's responded well to the Dittany. She was born to run, you see. I think she's just lacking in confidence."

—Newt Scamander, *Fantastic Beasts: The Crimes of Grindelwald*

COLORS

LIGHT YELLOW OCHRE	YELLOW OCHRE	RAW UMBER	BURNT UMBER	VANDYKE BROWN

CADMIUM RED DEEP	INDIAN RED	CADMIUM ORANGE	LIGHT GRAY	IVORY BLACK

RECOMMENDED SUPPLIES

Size 03 round brush	Size 01 round brush
Size 02 brush	Size 000 round brush
Size 02 round brush	White gel pen
Size 01 brush	Black gel pen

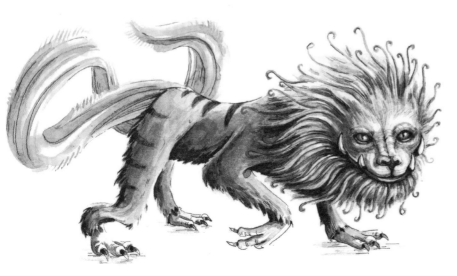

1. Use your size 03 round brush to apply light yellow ochre to almost all of the Zouwu's body. Leave the tail and claws for a later step.

2. While the first layer is still wet, apply a small amount of yellow ochre to the Zouwu's body. Use the tip of your brush to apply some color by just touching the paper with small dots. Let it fade with the water.

3. Use a size 02 brush and apply raw umber everywhere there is fur, except for the lighter areas. You can use this color on the face, too, but only a small amount, as the face is brighter than the rest of the body. Make sure to use your size 000 brush while applying the paint to the face, on the roots of the mane, around the eyelids, and on the side of the nose and the lower chin area.

4. When everything is completely dry, add some burnt umber on the darker parts of the Zouwu's body. Use a size 01 brush to form some of the fur behind the legs, under the chin, and around the mane.

5. Now, it's time to use Vandyke brown for the darkest parts of the fur and mane, using your size 01 brush. Make sure to leave some lighter areas without paint. And don't forget to add darker shades on the stomach and behind the legs.

6. When everything is dry, use a size 000 round brush and cadmium red deep to add an electric effect to the mane. While the cadmium red deep is still wet, add some shades with Indian red to the mane's roots and tips to create more dimension.

7. Now, start painting the tail! This part is a bit tricky, so I suggest practicing by studying the example illustration and painting some fish tails in advance. Take your size 03 round brush and dip it into clean water. Apply the water to any of the areas where you see pink in the example illustration, and then take a very small amount of cadmium red deep paint on your brush and touch the tail with the tip to let the color fade away. Use a clean tissue to stop the color from running out of control.

8. When everything is fully dry, use your size 01 round brush to add Indian red to the tail. Make sure to follow the direction of the lines on the tail while painting and use a clean, wet brush right after to smooth the transitions where necessary.

9. Add cadmium orange to the eyes and paint the lips with Indian red.

10. Start painting the claws with light gray. When this is dry, use your size 01 brush and add ivory black on the Zouwu's nails and on the darkest parts of the paws, such as in the shadows caused by the fur.

11. Use a size 000 brush to apply burnt umber to the fur to add some texture to the face. If you'd like, give the mane a fluffy look. Use a flat wash brush to create a half-transparent frizzy fur texture by putting a very small amount of paint on your brush and swinging your brush from the roots to the tip of the hairs.

12. Start with your white gel pen and add the white details on the tail. Then, whiten the fangs and add light to the eyes, the upper nose and the claws, and even on the mane if you need to add some brightness to the fur.

13. Finally, use your black gel pen to finalize the details on the tail. Don't use too much gel pen on the tail, as it may create a stiff look. Then, outline the fur on the Zouwu's body and mane and add any additional details to the claws and face.

Fawkes the Phoenix

"Fawkes is a phoenix, Harry. Phoenixes burst into flame when it is time for them to die and are reborn from the ashes."

—Albus Dumbledore, *Harry Potter and the Chamber of Secrets*

COLORS

RAW SIENNA

CADMIUM YELLOW

CADMIUM RED

CADMIUM RED DEEP

BURNT UMBER

VANDYKE BROWN

DARK INDIAN RED

LAMP BLACK

RECOMMENDED SUPPLIES

Size 03 round brush White gel pen

Size 02 round brush Black gel pen

Size 01 brush

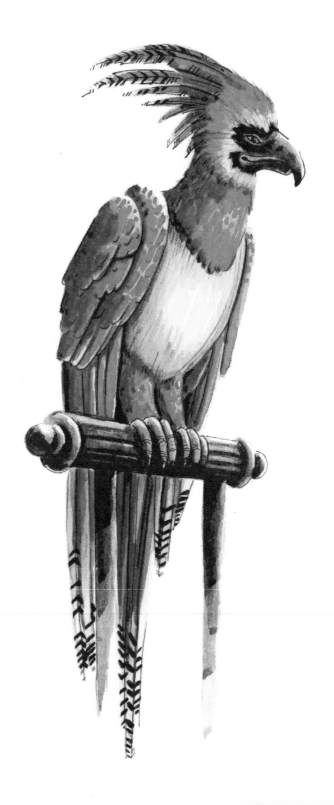

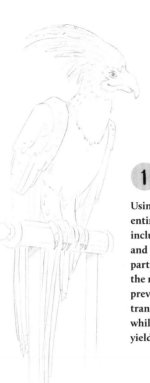

1

Using a size 03 round brush, paint the entire body of the phoenix with raw sienna, including its claws. Do not paint the beak and the stand just yet. When your paint is partially dry, apply cadmium yellow over the raw sienna layer. Try not to cover the previous layer fully, as watercolor paint has a transparent effect, and applying layers of color while varying the amount of coverage will yield a better result.

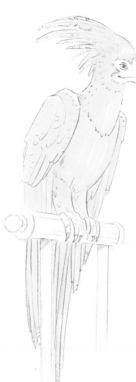

2

When the body is fully dry, use a size 02 round brush to apply cadmium red. Mix the color with water to allow for more variety in the shades, which will help create a feather texture.

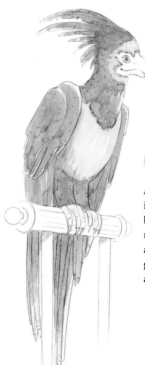

3

After applying red to the same parts indicated in the example painting, use a clean brush to blend the red with the yellow underneath. Try not to put too much pressure on your brush, and avoid rubbing the paper too hard. Be gentle, and the yellow and red should create an orange transition as you blend.

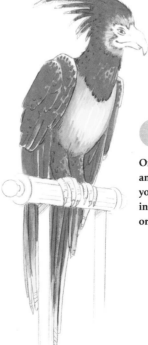

4

Once everything is dry, use a size 01 brush and begin applying cadmium red deep. Here, you can use the side of your brush to create an individual feather effect. Keep the yellows and oranges visible, as shown in the example.

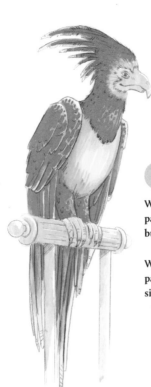

5 6

While the feathers are drying, paint the claws and beak with burnt umber.

While that layer is drying, paint the stand the phoenix is sitting on with burnt umber.

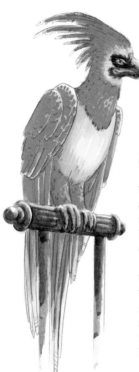

7 8

Wait for the first layer to dry, and then use Vandyke brown to add some shadows to the beak and claws for a more dimensional look.

When the stand is dry, use Vandyke brown to add any necessary shadows. Use a clean brush afterward to smooth the transition between the two colors.

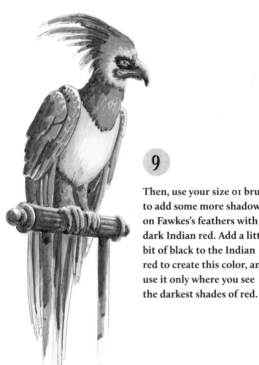

9

Then, use your size 01 brush to add some more shadows on Fawkes's feathers with dark Indian red. Add a little bit of black to the Indian red to create this color, and use it only where you see the darkest shades of red.

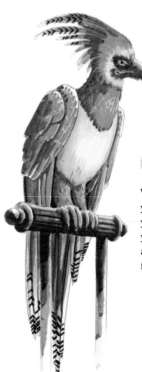

10

When everything is dry, and you are happy with how your painting looks, use your size 01 brush to add any remaining details to the feathers with lamp black.

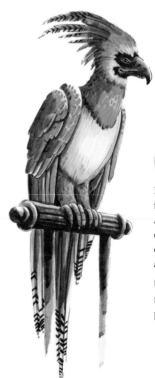

11 12

Finally, use your black gel pen to separate the feathers from each other where necessary. Add any details on the face and claws by outlining the borders between colors. Avoid outlining the full image, as that may not look as realistic.

Use your white gel pen to add small light reflections on Fawkes's eye and on the upper parts of his beak, wings, and claws.

Merperson

"The oldest recorded merpeople were known as sirens (Greece), and it is in warmer waters that we find the beautiful mermaids more frequently depicted in Muggle literature and painting. The Selkies of Scotland and the Merrows of Ireland are less beautiful, but they share that love of music which is common to all merpeople."

—Newt Scamander, *Fantastic Beasts and Where to Find Them*

COLORS

LIGHT YELLOW OCHRE BURNT SIENNA INDIAN RED YELLOW OCHRE

BURNT UMBER VANDYKE BROWN TURQUOISE LIGHT GRAY

RECOMMENDED SUPPLIES

Size 02 round brush White gel pen

Size 01 brush Black gel pen

Size 03 brush

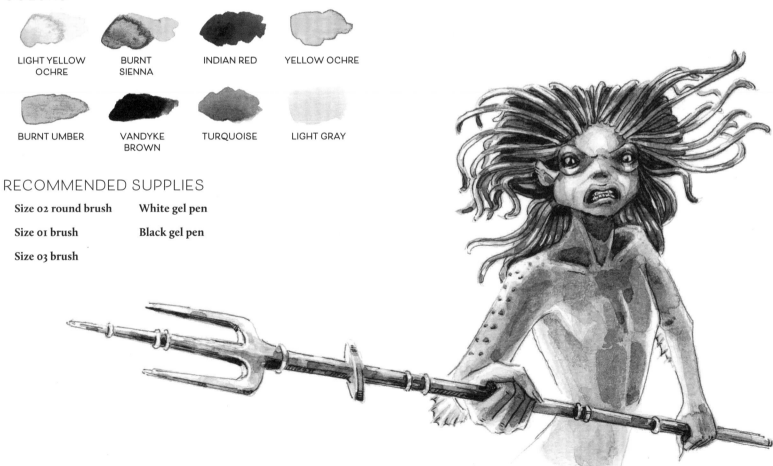

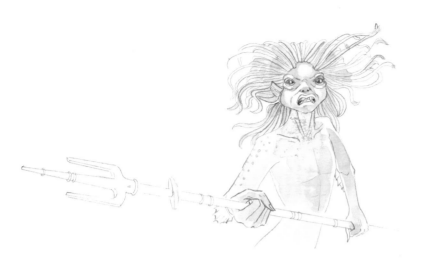

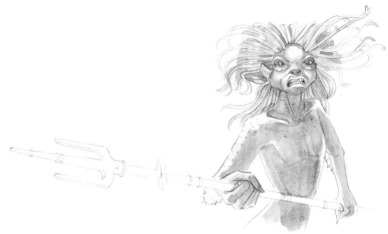

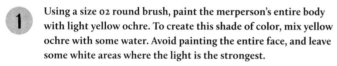

1 Using a size 02 round brush, paint the merperson's entire body with light yellow ochre. To create this shade of color, mix yellow ochre with some water. Avoid painting the entire face, and leave some white areas where the light is the strongest.

2 Once the first layer is dry, apply burnt sienna so that it covers almost the entire body of the merperson, but leaves some areas where the light reflects most. Use a clean, wet brush to smooth the transition between colors.

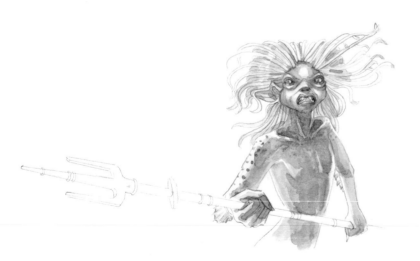

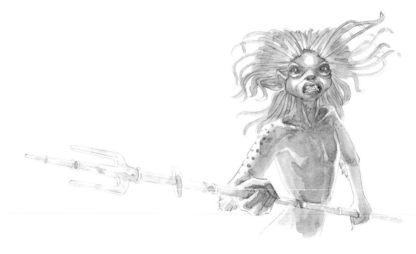

3 While the previous layer is still partially wet, apply some Indian red over the body to create the skin color. Don't forget to color the lips! Use the same color around the eyelids, but avoid painting over the reflected light at the top and bottom of the eyes.

4 5 Use a size 01 brush to paint the hair with yellow ochre. Try to keep the previous color (light yellow ochre and burnt sienna) on some areas, especially close to the skull and where the light reflects the most.

While everything is drying, paint the spear light gray. This material needs to reflect more light, so create several white areas to create a shiny, metallic effect.

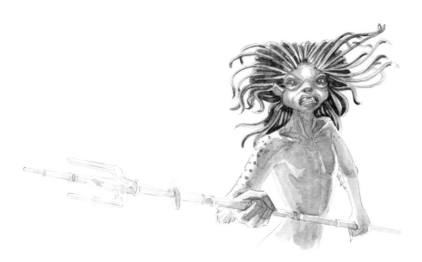

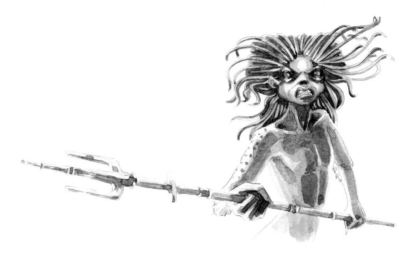

6 Then, use your size 01 brush to add some shadows to the merperson's hair with burnt umber. Use this color mostly underneath each strand of hair, leaving the patch of hair at the front of the hairline lighter to create more shine.

7 8 Apply Vandyke brown where the darkest shadows appear on the body in the example illustration. Keep in mind that the light source is on the upper left side of the page (behind the merperson), so the shadows should appear mostly on the front left side of the merperson's body as well as the inner right side of the body and face.

Use dark gray (about 20 percent water with gray) to paint the bottom edges of the spear, and use contrasts to reflect its metal texture.

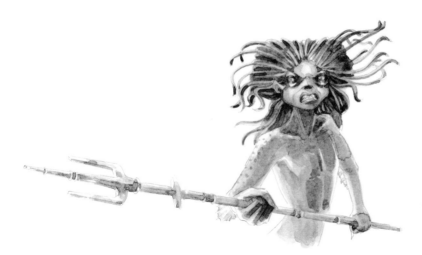

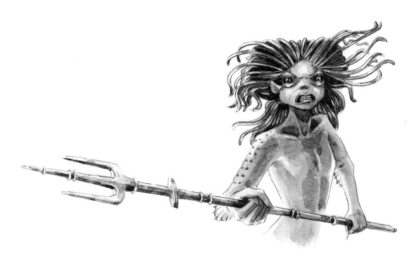

9 Now add an adjustment layer on the merperson to make them look a bit more faded, as if they are underwater. Once everything is dry, use a size 03 brush and apply some turquoise diluted with lots of water. Apply this mixture to the merperson's entire body.

10 11 Use your white gel pen to add some brightness to the hair, eyes, teeth, and on the spear if necessary.

Then use your black gel pen to create more specific facial details, such as the mouth shape and teeth, by adding black to the inner part of the mouth, as seen in the example illustration. Also, feel free to use your black gel pen on the pupils and the edges of the eyes, as well as to the hair to define the shape.

DIFFICULTY: ⚡⚡⚡

Basilisk

[Harry reading the paper from the book taken by Hermione]

"Of the many fearsome beasts that roam our land, none is more deadly than the Basilisk. Capable of living for hundreds of years, instant death awaits any who meet this giant serpent's eye. Spiders flee before it."

—Harry Potter, *Harry Potter and the Chamber of Secrets*

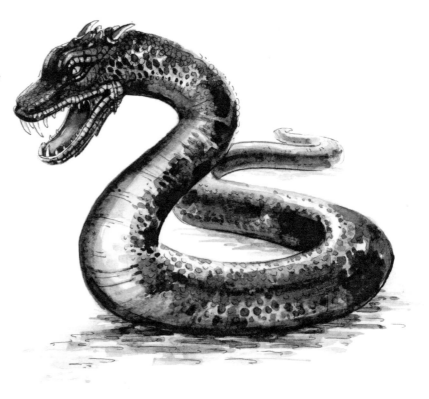

COLORS

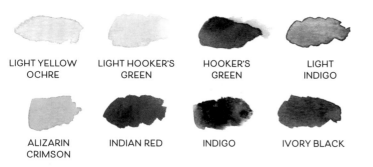

LIGHT YELLOW OCHRE LIGHT HOOKER'S GREEN HOOKER'S GREEN LIGHT INDIGO

ALIZARIN CRIMSON INDIAN RED INDIGO IVORY BLACK

RECOMMENDED SUPPLIES

Size 03 round brush Size 02 brush

Size 02 round brush White gel pen

Size 01 brush Black gel pen

1. Using your size 03 round brush, apply a generous amount of light yellow ochre to almost the entire body of the Basilisk. Leave some white areas for light reflection.

2. While the first layer is still wet, apply light Hooker's green. This will be the base color of the skin, so make sure to apply it everywhere except for the lightest parts and around the mouth and eyes.

3. Let the paint dry completely and then use a size 02 round brush to apply Hooker's green. Add a small amount of paint to your brush and tilt your brush so that you can use the tip to apply small dots to create the snakeskin texture.

4. When all the paint is dry, use a clean, wet brush to fade the darker green with the lighter areas to add dimension and illustrate the Basilisk's round shape.

5. When this piece is dry, use a size 03 or bigger brush to apply a layer of light indigo to the entire body of the Basilisk. This adjustment layer will help create a faded shade to the Basilisk, as if it has been underground for a long time.

6. While everything is drying, paint the Basilisk's inner mouth with alizarin crimson.

7. Then, use a size 01 brush to add Indian red to the inner mouth. With this color, outline the mouth to highlight the teeth and paint closer to the throat where the shadows appear the most, giving it a sense of depth.

8. Now, use your size 02 brush to paint the darkest part of the Basilisk's skin with indigo. If necessary, use this shade to highlight the Basilisk's skin texture a bit more. Use the tip of your brush to add some dots on the skin to highlight the snakelike texture.

9. Paint ivory black on the darkest areas, like under its belly, around its eyelids, and around its throat.

10. Finally, use your white and black gel pens where necessary. For instance, use your black gel pen to create more accurate skin texture by adding a few lines on the neck to indicate the direction of the Basilisk's body and shape.

Centaur

"You have no business here, Centaur! This is a Ministry matter."

—Dolores Umbridge, *Harry Potter and the Order of the Phoenix*

COLORS

LIGHT YELLOW OCHRE **RAW UMBER** **VANDYKE BROWN**

DARK VANDYKE BROWN **LAMP BLACK**

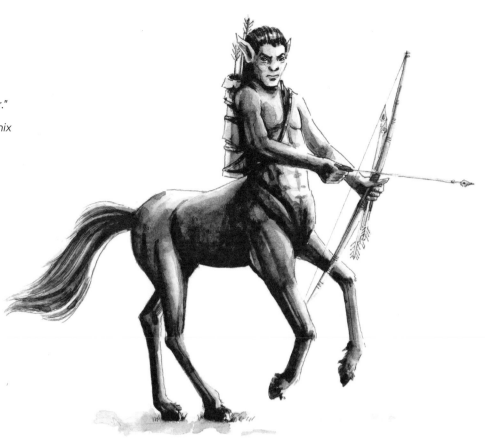

RECOMMENDED SUPPLIES

Size 02 round brush	White gel pen
Size 01 brush	Black gel pen

1. Using your size 02 round brush, apply light yellow ochre to the Centaur's entire body, leaving some areas white on the right side of the body to indicate the light source.

2. Let everything dry and then start adding raw umber to the entire body to create the base color of the Centaur's skin, making sure to avoid the lightest areas for light reflection. When everything is dry, use a clean, wet brush to fade the raw umber and create a smooth transition.

3. When the paint is completely dry, add Vandyke brown where the darker shades appear the most. Use your size 01 brush around the face and legs of the Centaur to avoid any mistakes. Start with the larger areas of shadow and move to the finer shadow details. When the paint is dry, use a clean, wet brush to blend the darker areas with the lighter areas to create the smooth, rounded shape of his body.

4. Mix the Vandyke brown with about 20 percent lamp black to create a darker shade. Then, use a size 01 (or thinner) brush to apply dark Vandyke brown to the darker parts of the Centaur's body, such as under his belly, at the root of his tail, and on his back.

5. Paint the Centaur's hair with lamp black, leaving some light parts in the front to add a shiny reflection.

6. Finally, use your gel pens to add details to the Centaur's face, as well as the bow and arrows, which can be tricky to do with a brush.

Niffler

"For the last time, you pilfering pest—paws off what doesn't belong to you!"

—Newt Scamander, *Fantastic Beasts and Where to Find Them*

COLORS

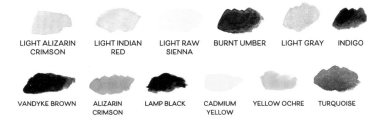

LIGHT ALIZARIN CRIMSON	LIGHT INDIAN RED	LIGHT RAW SIENNA	BURNT UMBER	LIGHT GRAY	INDIGO
VANDYKE BROWN	ALIZARIN CRIMSON	LAMP BLACK	CADMIUM YELLOW	YELLOW OCHRE	TURQUOISE

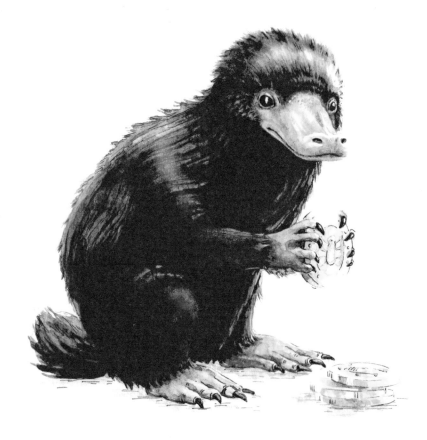

RECOMMENDED SUPPLIES

Size 02 brush 6mm flat wash brush

Size 03 brush White gel pen

Size 01 brush Black gel pen

1. Start by applying light alizarin crimson to the Niffler's feet, hands, and snout. Leave some white gaps for light reflection.

2. While the previous layer is still wet, apply some light Indian red where the pinkish color is the strongest. Avoid using too much color on your brush, and, instead, paint a very small amount of this color on a separate piece of paper to test the shade. Then, use a clean, wet brush to apply this color and blend it with light alizarin crimson.

3. Using a size 02 brush, apply light raw sienna over the previous layers that you've just painted. There is no need to wait for the previous layer to fully dry, as you want the colors to mix together.

4. Then, wait for everything to dry completely, and use burnt umber to add some shadows to the nose, hands, and feet.

5. Use a size 03 brush to paint the Niffler's fur with light gray. Paint almost all of the fur while leaving some areas white for, light reflection.

6. Use your size 03 brush to shade the fur with light gray. Use the tip of the brush by tilting it and gently touching the paper to leave some dots that will help to create the look of his fur sticking up. Leave some white gaps for light reflection.

7. While the previous layer is still wet, use a size 02 brush to add indigo all over the fur. Paint in the direction of his fur, and leave some lighter parts to catch the light reflections.

8. While the Niffler's body dries, use Vandyke brown to add more shadows to the feet, hands, and nose. Use your size 01 brush and carefully create shadows that accent and define his anatomy.

9. When everything is dry, use your size 01 brush and apply a very small amount of alizarin crimson. Then, use just the tip of your brush to add some tiny dots around his eyes and forehead. Use this same color between the lips, focusing mostly on the inner part of the lower lip.

10. Use your size 01 brush and paint all of the fur with lamp black. His fur wraps around his body, so that should give you an idea about the fur placement. Start placing a large amount of black where you see no light at all. Then, go section by section and paint the fur by using the tip of your brush, creating lines that will illustrate coarse fur. Use a clean brush to smooth the color transitions where necessary. Use a 6mm flat wash brush to create a better furry effect if you'd like.

11. For the gold coins, use your size 02 brush and begin painting them with cadmium yellow. Avoid painting every part, and leave some large white areas to create a reflective look. After the yellow dries, use yellow ochre to add a second shade. Use both smooth edges, along with some sharp edges between the yellow ochre and the white areas, to create a more metallic look.

12. Before adding the details with your gel pens, use your size 03 brush and dilute turquoise with water. Apply this color all over the Niffler's fur to create a bluish reflection.

13. Use your white gel pen to add additional brightness to the coins, the inner parts of the Niffler's eyes, the upper part of the nose, and the fingers, as shown in the example illustration.

14. Use your black gel pen to sharpen any borders around the Niffler, like on his eyes, eyelids, nostrils, fingers, and nails. Use your black gel pen only where you see the sharp black lines in the example illustration.

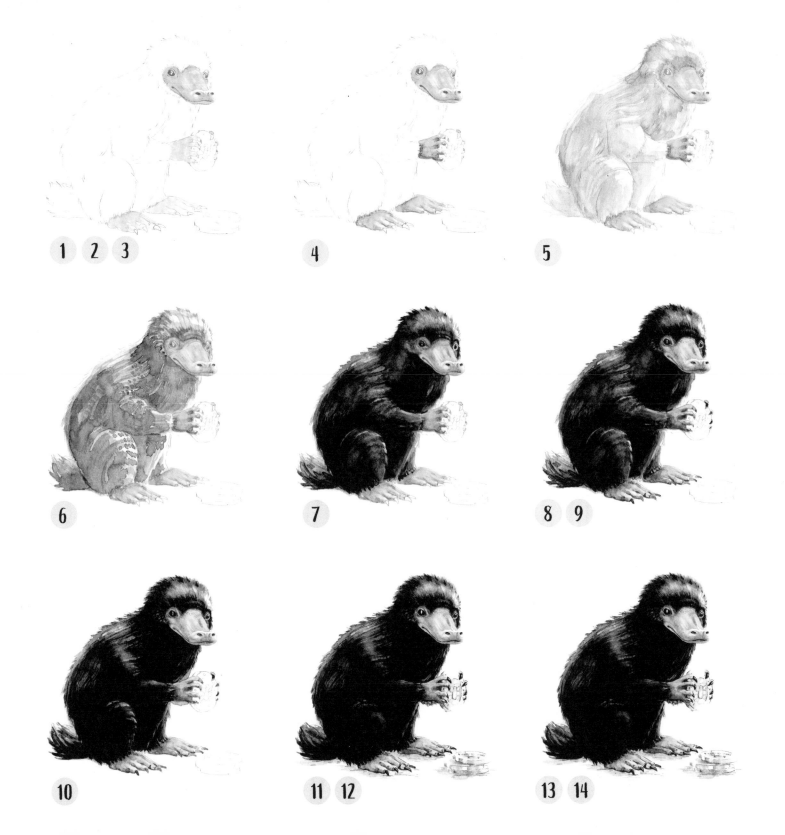

1 2 3

4

5

6

7

8 9

10

11 12

13 14

Crookshanks and Scabbers

"This cat isn't mad. He's the most intelligent of his kind I've ever met."

—Sirius Black, *Harry Potter and the Prisoner of Azkaban*

COLORS

LIGHT CADMIUM YELLOW	YELLOW OCHRE	BURNT SIENNA	BURNT UMBER
LIGHT ALIZARIN CRIMSON	GRAY	DARK GRAY	LIGHT RED

RECOMMENDED SUPPLIES

Size 03 brush	Size 000 brush
Size 02 round brush	White gel pen
Size 01 brush	Black gel pen

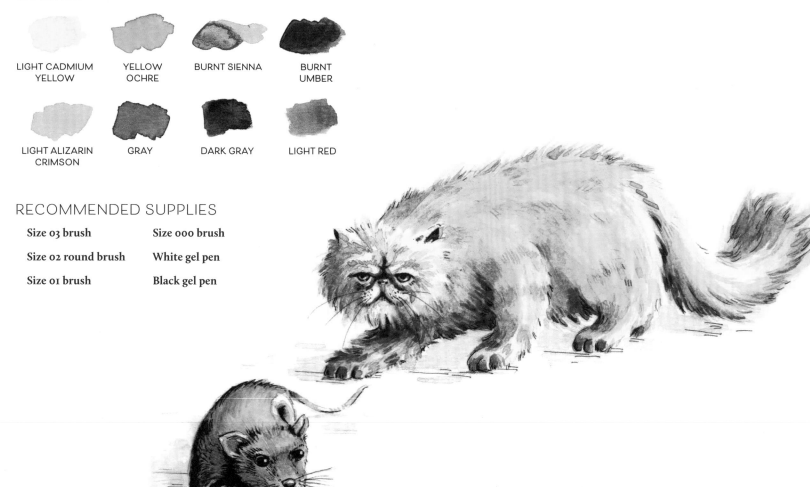

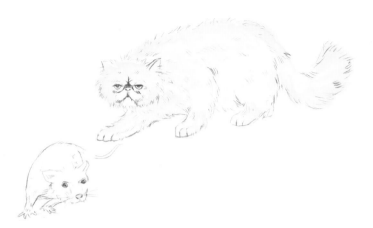

1 Start by painting Crookshanks the cat. Using your size 03 brush, apply light cadmium yellow to his entire body, including the tail, while leaving some areas of white for light reflections.

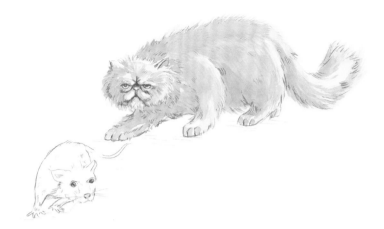

2 When the body is fully dry, use your size 02 round brush to apply yellow ochre, which will create Crookshanks's base color. Avoid having too much paint on your brush, and always paint in the direction of the fur.

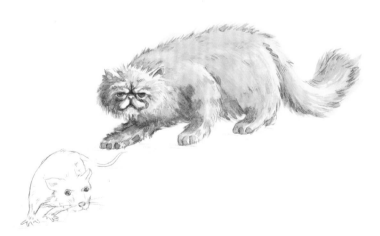

3 When the previous layer is fully dry and you are happy with the general shape of the cat, it's time to add some details with burnt sienna. Use your size 01 brush and paint the darkest shades on the left side of Crookshanks's body. Fill in the cat's eyes with this color, and don't forget to add some shades under his eyes, as well as in and around his mouth, and at the bottom part of the tail where you see a strong shadow. Then add the subtle stripes around his legs and on his forehead.

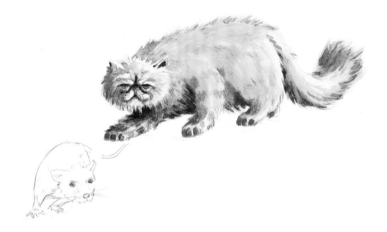

4 Use a size 000 brush with a very small amount of burnt umber to carefully paint around his eyes and mouth. Make sure that you are painting in the direction of the fur.

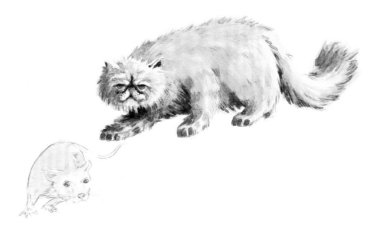

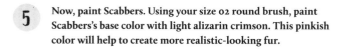

5 Now, paint Scabbers. Using your size 02 round brush, paint Scabbers's base color with light alizarin crimson. This pinkish color will help to create more realistic-looking fur.

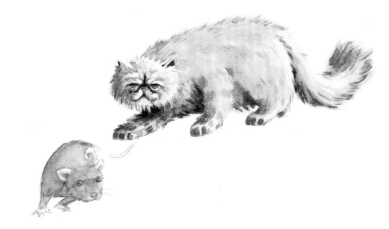

6 When the base color is dry, use your size 01 brush to paint his body gray. Don't forget to leave his ears, tail, and feet pink.

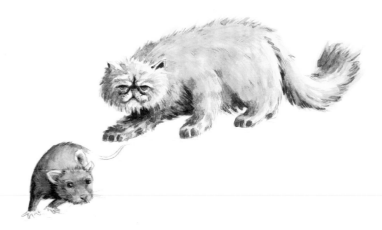

7 Then, use your size 000 brush to apply dark gray, adding any necessary shadows to create more definition in the fur and dimension to his overall shape.

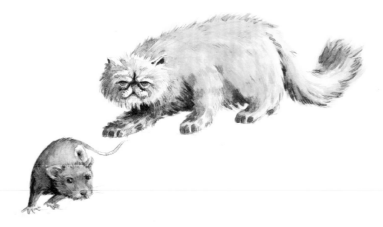

8 Use the same brush to apply some shading on his ears and front paws with light red.

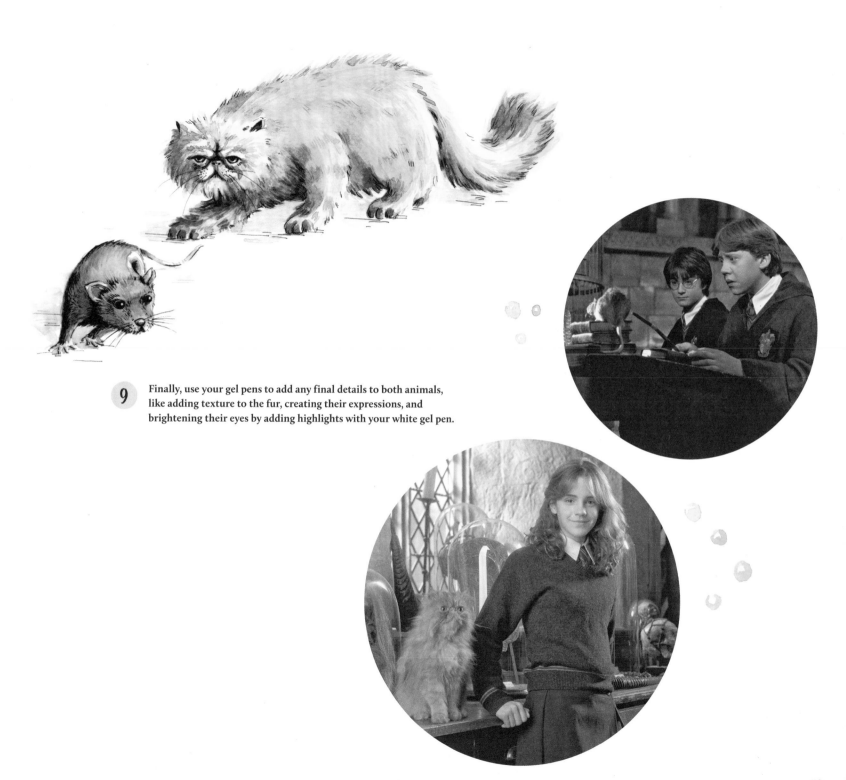

9 Finally, use your gel pens to add any final details to both animals, like adding texture to the fur, creating their expressions, and brightening their eyes by adding highlights with your white gel pen.

Swooping Evil

"This, the locals call Swooping Evil. Not the friendliest of names. It's quite an agile fella."

—Newt Scamander, *Fantastic Beasts and Where to Find Them*

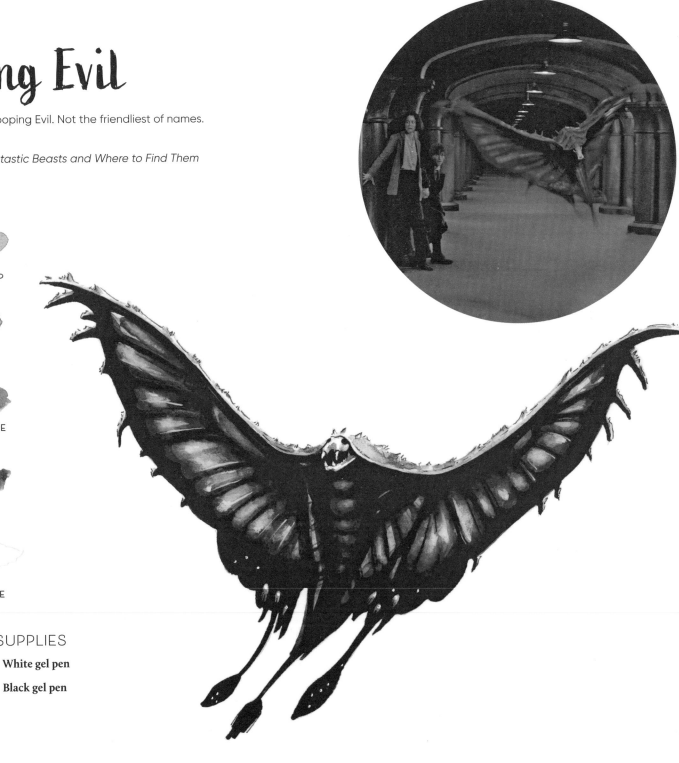

COLORS

LIGHT GRAY

LIGHT SAP GREEN

SAP GREEN

MAUVE

CERULEAN BLUE

TURQUOISE

INTENSE GREEN

INDIGO

LAMP BLACK

WHITE

RECOMMENDED SUPPLIES

Size 01 brush

Size 03 brush

Size 000 brush

White gel pen

Black gel pen

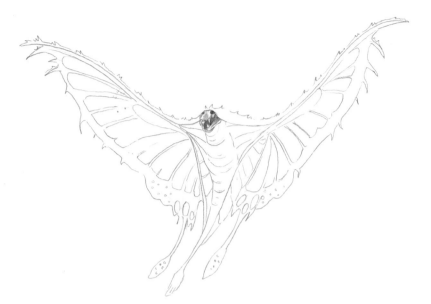

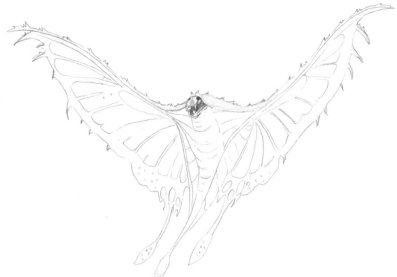

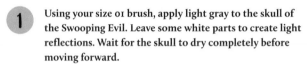 Using your size 01 brush, apply light gray to the skull of the Swooping Evil. Leave some white parts to create light reflections. Wait for the skull to dry completely before moving forward.

Then, use your size 01 brush to paint the tops of his wings with light sap green.

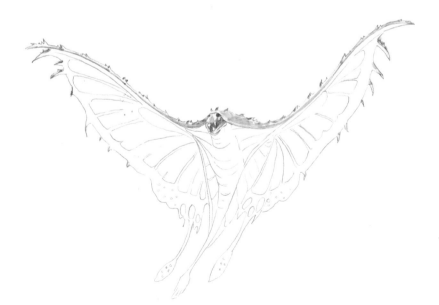

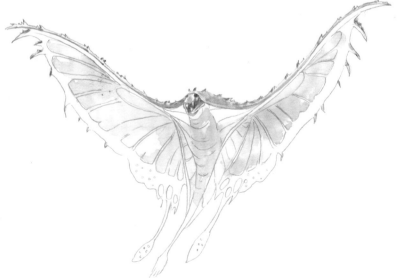

While the previous layer is still wet, paint the darker areas at the tops of his wings with sap green to create more dimension.

Then, use your size 03 brush and paint the inner part of the wings and body with mauve. This will be a base color for its iridescent effect, so don't worry about staying in the border lines.

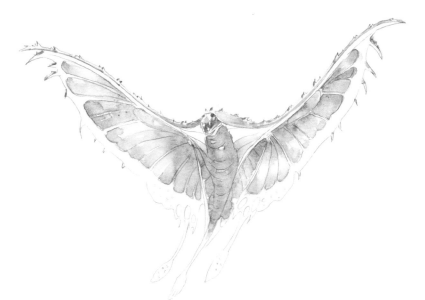

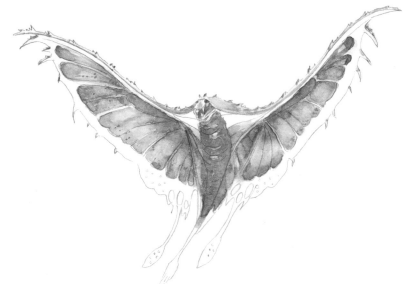

5 While the previous layer is still wet, paint the inner body with cerulean blue, creating a light-blue watercolor effect. Because it's still wet, it will be easy to catch this watercolor effect; if you aren't seeing this effect yet, use a clean brush to wet the area with a small amount of water, and dip your brush into cerulean blue. Try not to have too much paint on your brush, and paint where the blue reflects the strongest. Touch those areas with the tip of your brush, and let the water carry the color away.

6 Use your size 01 brush and add some turquoise to the inner wings to enrich the effect. Then, use a clean brush to soften the transition between colors.

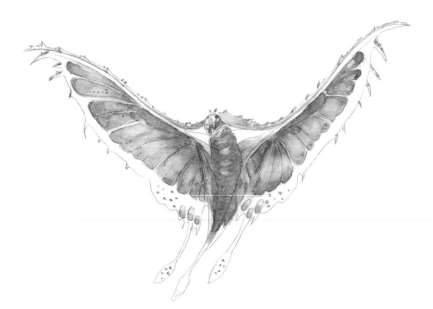

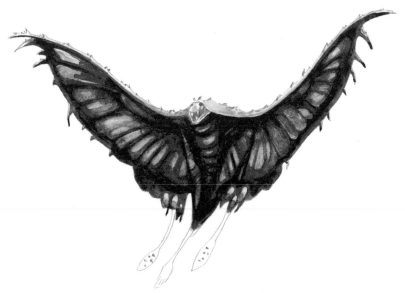

7 Use your size 1 brush to apply intense green to the bottoms of the wings.

8 Wait for everything to fully dry, then use a size 000 brush to add indigo. Pay close attention to the direction of lines to create a similar wing shape on each side. After the wings dry, use a clean brush and blend the indigo into the other colors to gently soften the borders.

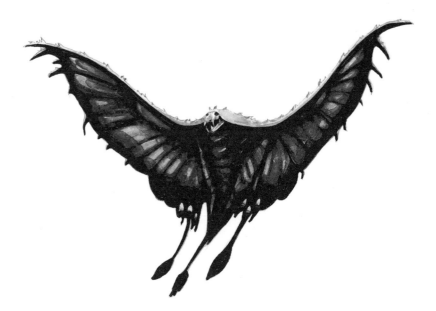

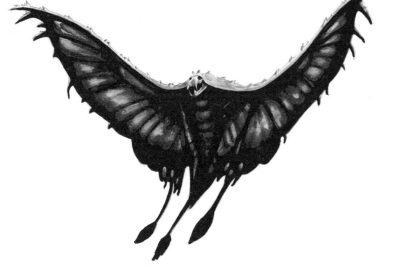

9 When that layer is dry, use your size 000 brush to add the darkest shadows with lamp black. Avoid using too much water while diluting your color so your black will retain its dark shade.

10 Now, use white to paint tiny dots on the brightest parts of the wings and use a clean, wet brush to paint around those dots to help the color travel and create a smooth transition with the other colors.

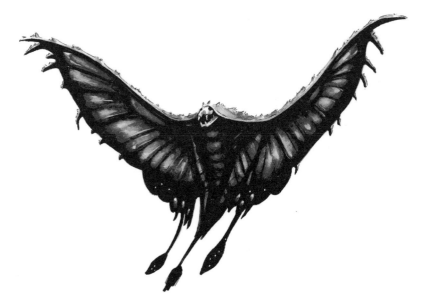

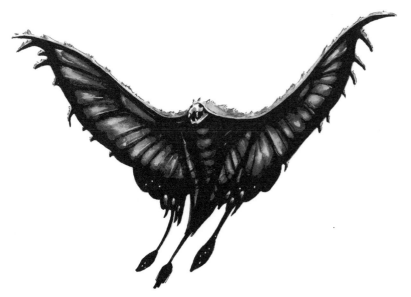

11 Finally, use your white and black gel pens for any final details around the face, body, and tail. Add some white dots around its tail and lower wings alongside its inner wings where you see bright white in the example illustration.

12 Use your black gel pen to add details to the face and to the top of the wings where you see green in the example illustration.

Hungarian Horntail

"Come on, Harry. These are seriously misunderstood creatures. Although, I have to admit that Horntail is a right nasty piece of work. Poor Ron nearly fainted just seeing him."

—Rubeus Hagrid, *Harry Potter and the Goblet of Fire*

COLORS

LIGHT YELLOW OCHRE

YELLOW OCHRE

LIGHT ALIZARIN CRIMSON

BURNT UMBER

BURNT SIENNA

VANDYKE BROWN

CADMIUM YELLOW

CADMIUM ORANGE

LAMP BLACK

RECOMMENDED SUPPLIES

Size 02 round brush

Size 03 brush

Size 000 brush

Size 01 brush

White gel pen

Black gel pen

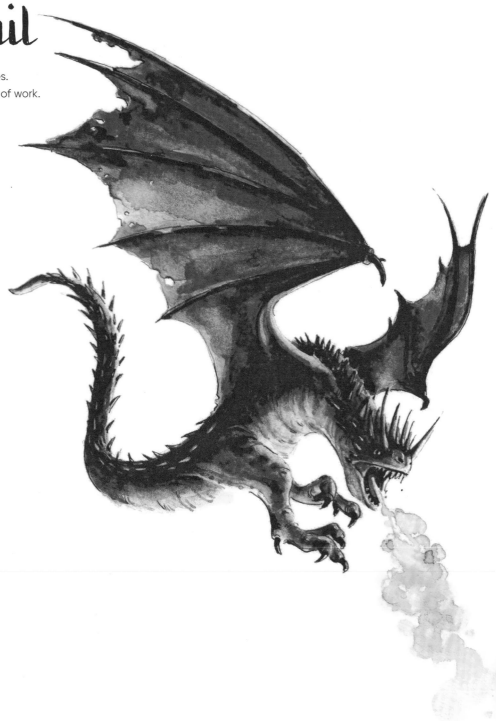

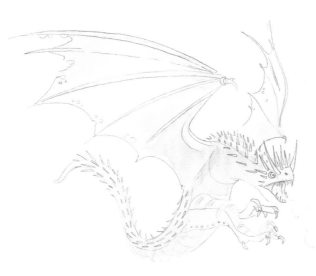

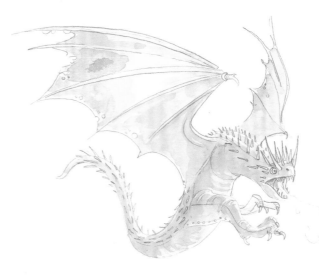

1. Use a size 02 round brush to apply light yellow ochre to the entire body of the dragon.

2. While it's still wet, apply a layer of yellow ochre to give it more texture and start building the general shape. Be mindful of the light source—the fire—so the back of the dragon will be darker and the front will be brighter.

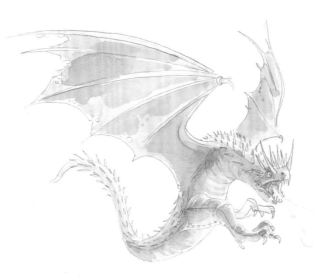

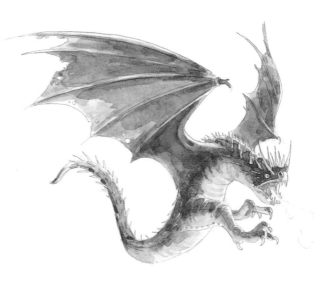

3. While the previous layer is still partially wet, use your size 03 brush to add some light alizarin crimson all over the dragon's body. This color will make the dragon look alive. Then, use a clean brush to soften the transition between colors.

4. Use your size 02 round brush to apply burnt umber as the base color of the back, leaving the stomach alone for now. Try not to paint his horns here, but if it's too much trouble, you can always use your white gel pen later to brighten them up. Use a larger brush while applying this color over the wings, and remember to always smooth out the transition between shades.

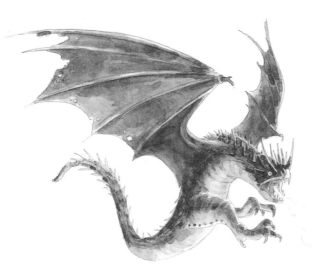

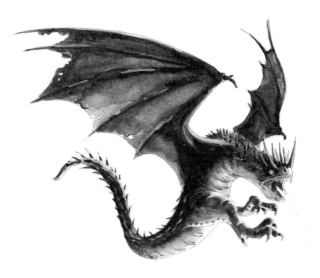

5 Paint burnt sienna on the dragon's upper head and back and almost all of the wings (except for the very bottom parts) to give it a firelike color.

6 Now, paint the body with Vandyke brown. Use a size 000 brush for the smaller areas. This color should mostly be applied behind the head and tail, under the wings, and on the tips of the bones of the wings. Use a larger brush while painting the larger parts of the wings, and always make sure the color is blending nicely with the other colors.

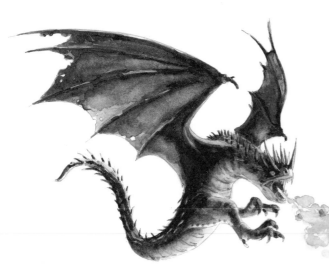

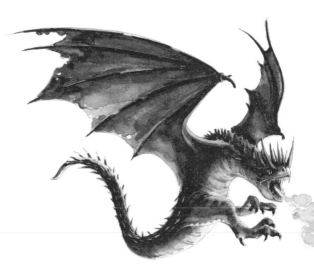

7 To add the fire, use a size 01 brush and begin painting with cadmium yellow. Use a clean, wet brush to soften the edges and make the transition fluid. While it's still wet, add some orange to the fire, but avoid having too much paint on your brush. If needed, use a clean tissue to keep the colors from blending too much with one another. When it's dry, soften some areas with a clean, wet brush.

8 After you've painted the fire, use the same yellow and orange on some parts of his body to reflect the light the fire creates, such as the tip of his nose and on his belly, which receive the most light from the fire in the example illustration.

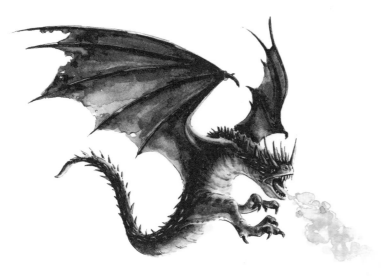

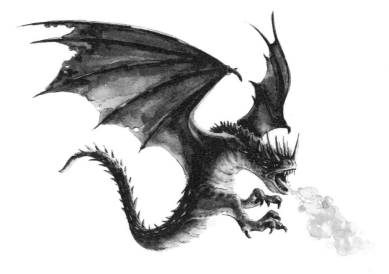

9 Then, use lamp black to paint the darkest areas of the dragon. It's best to use a size 01 or 000 brush on the details of the wings and nails. Use a larger brush on larger areas to avoid brush marks. Use a clean brush to soften the transitions between colors.

10 Finally, use your gel pens for the final details. After using a white gel pen to brighten up the lighter parts of the dragon, make sure to paint those white areas with yellow or orange to indicate the warm light source.

Cornish Pixies

DIFFICULTY: ⚡⚡⚡

"The Pixies can be devilishly tricky little things. See what you make of them."

—Luna Lovegood, *Harry Potter and the Order of the Phoenix*

COLORS

LIGHT INDIGO

CERULEAN

INDIGO

LIGHT ALIZARIN CRIMSON

RECOMMENDED SUPPLIES

Size 03 round brush White gel pen

Size 01 brush Black gel pen

Size 000 brush

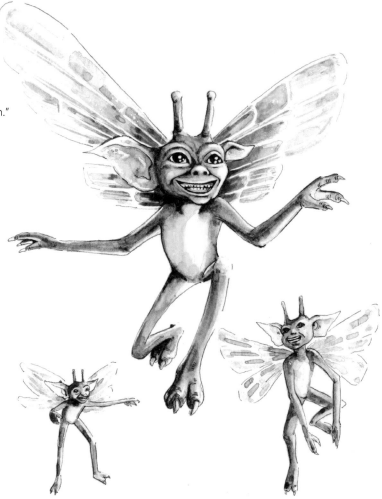

1. Start by painting the largest Pixie first. Using your size 03 round brush, paint the body of the Cornish Pixie with light indigo, while leaving the wings, mouth, and eyes blank.

2. When the first layer dries, paint the Pixie's body with cerulean blue where it's indicated in the example illustration. Leave the Pixie's stomach and inner ears blank for now. When this layer is fully dry, use a clean, wet brush to smooth the transition between the two colors.

3. Use your size 01 brush to add indigo to the darkest parts of the Pixie's body. Be mindful of the example and make sure to study the Pixie's anatomy carefully before painting.

4. When the Pixie's body is completely dry, paint the wings. Use your size 03 brush and paint them with light indigo. While the wings are still wet, add indigo to only the areas that are close to the Pixie's back. Let the water carry this darker shade into the lighter one to create a nice watercolor effect. Later on, add the details of the wings with a white gel pen.

5. Using your size 000 brush, apply light alizarin crimson to the Pixie's gums near the teeth. Use the same color on his fingertips and inner ears, too.

6. When everything is fully dry, use your white gel pen to add any remaining details on the wings. Use your pen to draw lines on the wings, which creates a more layered and detailed look. You can also add some white dots to give the wings a magical quality.

7. Finally, use a black gel pen to help define the whites around the eyes, the inner mouth, and anywhere you need darker borders.

8. Repeat steps 1 through 7 with the remaining Pixies.

Thestral

"They're called Thestrals. They're quite gentle, really, but people avoid them because . . . they can only be seen by people who've seen death."

—Luna Lovegood, *Harry Potter and the Order of the Phoenix*

COLORS

LIGHT COBALT BLUE

LIGHT INDIGO

INDIGO

LAMP BLACK

RECOMMENDED SUPPLIES

Size 01 brush

Size 000 brush

Size 03 brush

White gel pen

Size 02 brush

Black gel pen

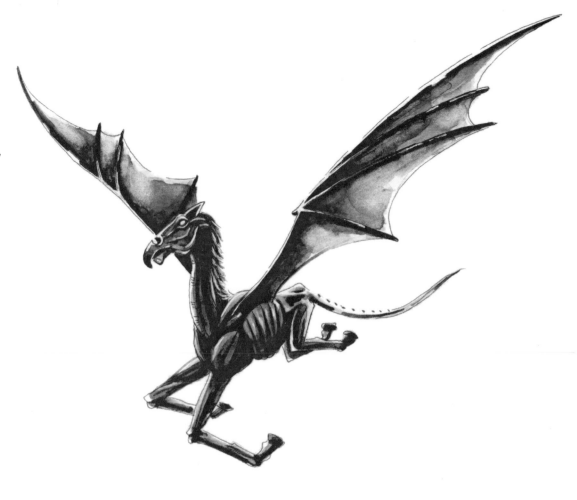

1. Using your size 01 brush, paint the entire body of the Thestral with light cobalt blue, leaving some white areas where necessary.

2. While the body is still wet, use your size 03 brush and apply indigo to the wings. Use this color only where the darker shades appear, leaving the light areas alone for now. The indigo will fade into the light cobalt blue. If it's not fading enough, use a clean brush to add a small amount of water and blend the color where needed.

3. Then, use a size 02 brush to add light indigo to the entire body of the Thestral. Be sure to leave some white areas, as shown in the example illustration.

4. While you let that layer dry, use your size 01 brush to add indigo to the body of the Thestral. Be mindful of where you are painting, as the dark shadows will determine the creature's anatomical shape. When you finish with this color, use a clean, wet brush to smooth the transitions if necessary.

5. Use a size 000 brush to add the remaining dark shadows to the Thestral with lamp black. This color appears mostly on the wings, ribcage, and neck and below the body. Be mindful painting around the face, and avoid having too much paint on your brush. Use a clean, wet brush to smooth the transition between black and indigo.

6. Finally, use your white gel pen to add any necessary white lines. And use your black gel pen to add any details, especially on the face and the mane.

DIFFICULTY: ⚡⚡⚡

Buckbeak the Hippogriff

"Come on, Buckbeak, come and get the nice dead ferret."

—Hermione Granger, *Harry Potter and the Prisoner of Azkaban*

COLORS

LIGHT RAW
UMBER

LIGHT GRAY

GRAY

DARK GRAY

LAMP BLACK

RECOMMENDED SUPPLIES

Size 01 brush White gel pen

Size 02 brush Black gel pen

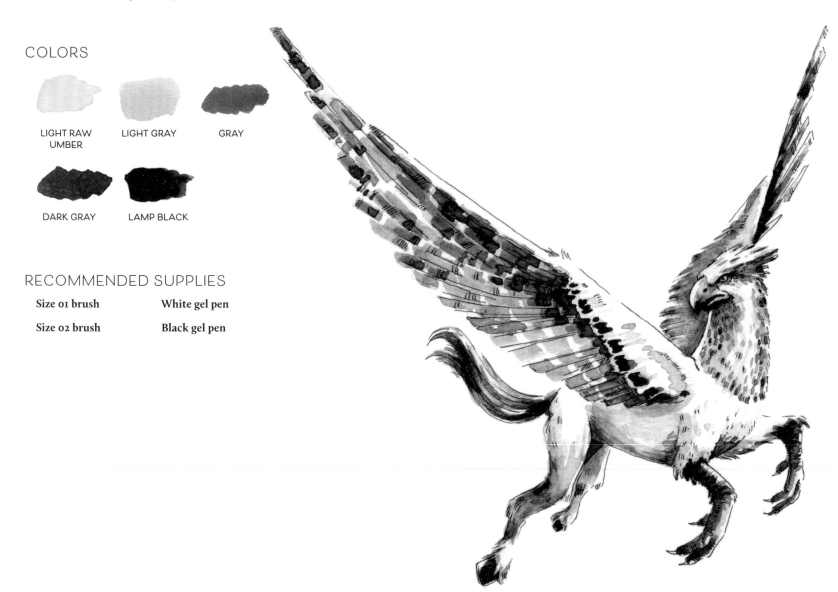

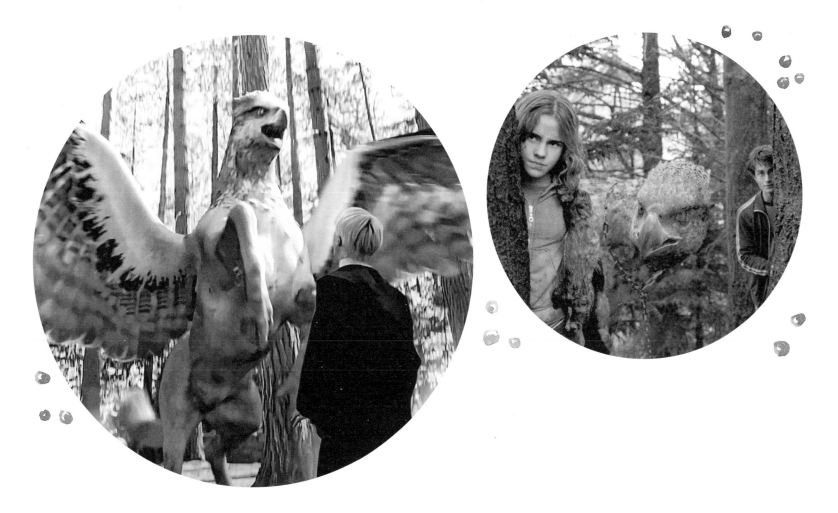

1. Using a size 01 brush, apply light raw umber to Buckbeak's beak, cheek, lower neck area, and claws.

2. Let that layer dry, and then use a size 01 brush to add light gray to the tip of your brush. Tilt your brush and touch the paper with just the tip of it to create some light gray feathers on Buckbeak's neck and head. Buckbeak has mostly white feathers, so make sure to leave some white areas for light reflections.

3. Then, use your size 02 brush to apply light gray to the wings. Hold your brush vertically, and then tilt it and use the side of it to create a beautiful feather effect on the wings. Try not to paint all of the feathers and leave some white areas to create a pattern.

4. Use your size 02 brush to apply gray. Follow the same technique to place gray where necessary. Don't forget to paint Buckbeak's lower belly and lower legs, where the shades appear darker.

5. Now, apply dark gray where the feathers are the darkest and where there are more shadows. When painting around Buckbeak's face, I recommend using a size 01 brush to avoid mistakes. Be mindful of the amount of gray you use, as he needs to appear mostly white.

6. Then, use your size 02 brush to add lamp black details to Buckbeak's wings. Try not to put too much paint on your brush, and keep it tilted at all times to allow more control while you are painting.

7. Use your size 01 (or thinner) brush to add details to the beak, eyes, tail, claws, and feathers. Buckbeak's base color is white, so avoid using darker shades here, as this may compromise his original color.

8. Finally, use your white and black gel pens to add details where necessary, like on the feathers and the face and around the claws. Don't use the gel pen too much on the wings by outlining the feathers, as this will make the transitions look too sharp, and he will lose the natural fluffy look that he has.

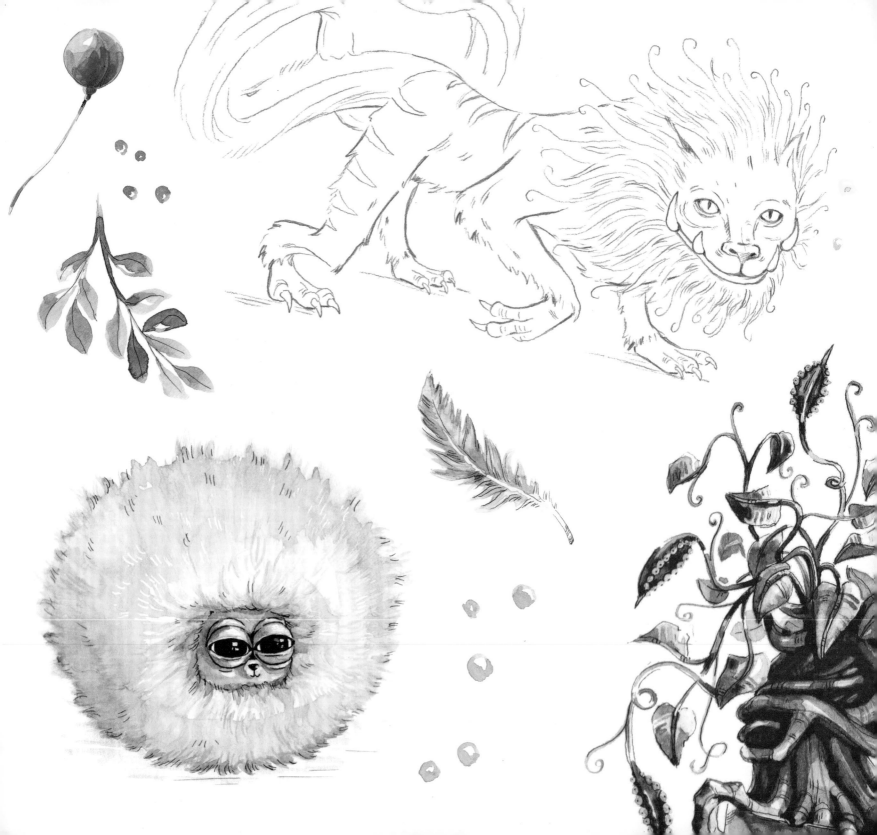

Watercolor Sketches

The following pages contain sketches corresponding to each illustration and set of instructions, and are printed on premium watercolor paper. Just select the sketch you'd like to watercolor, gently tear it out, and you're ready to begin painting your very own magical creations!

Hedwig the Snowy Owl

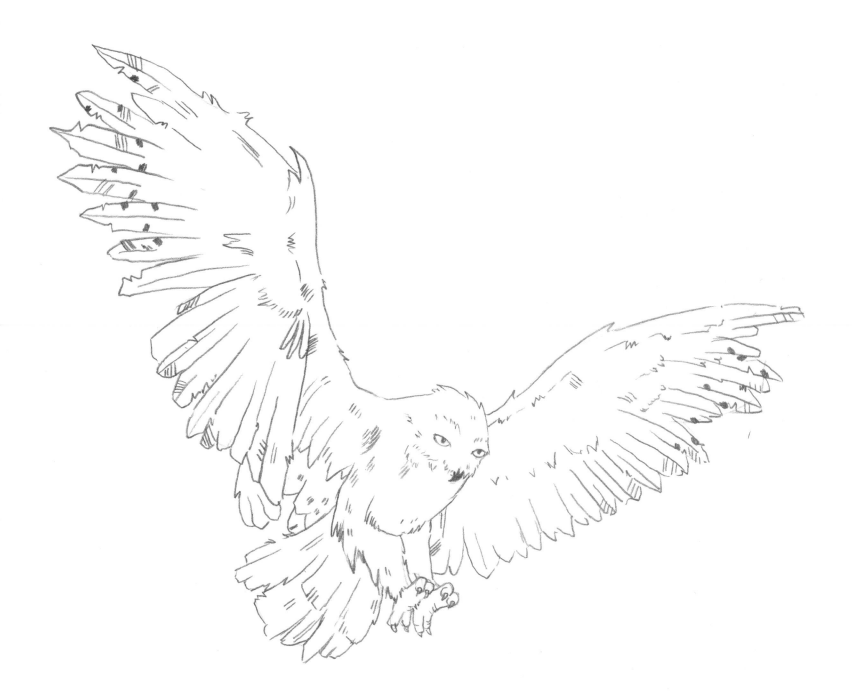

Dobby the House-Elf

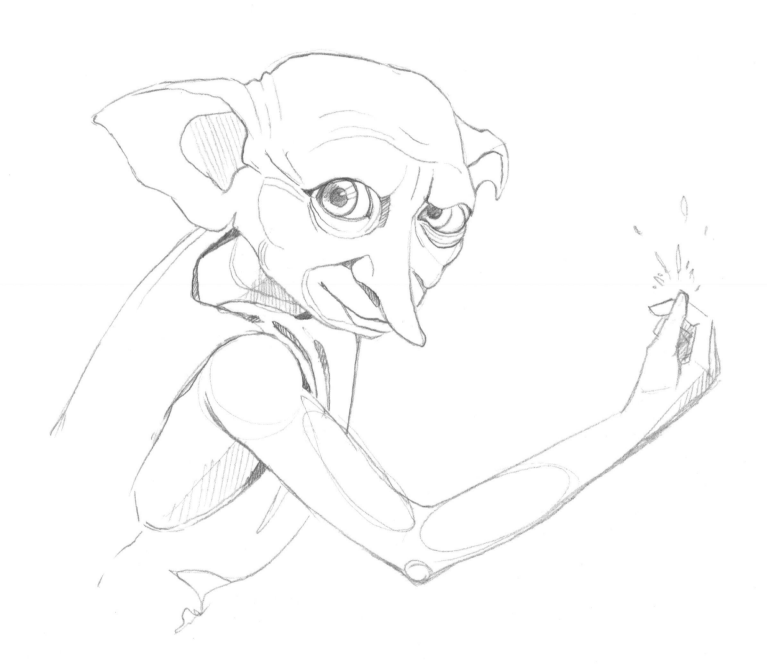

Aragog the Acromantula

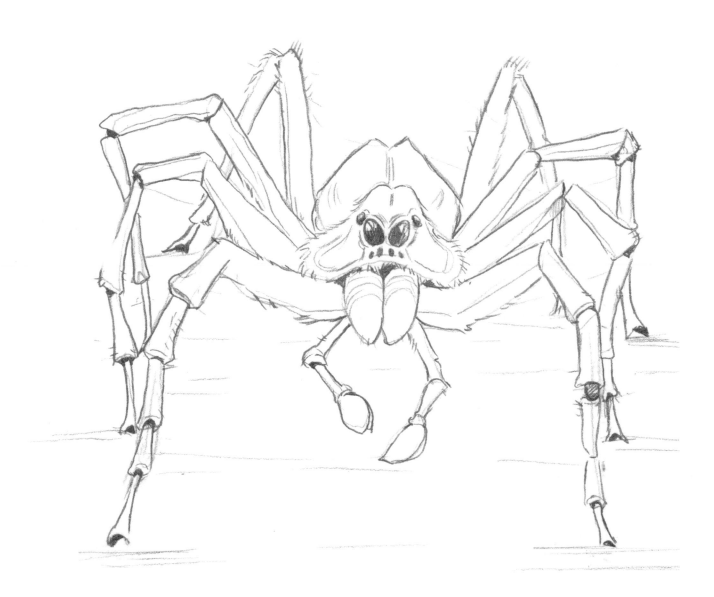

Pickett the Bowtruckle

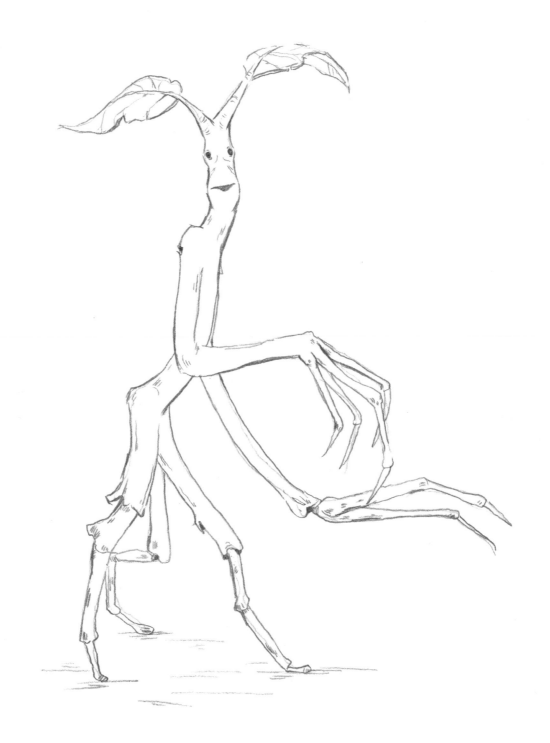

Mimbulus Mimbletonia

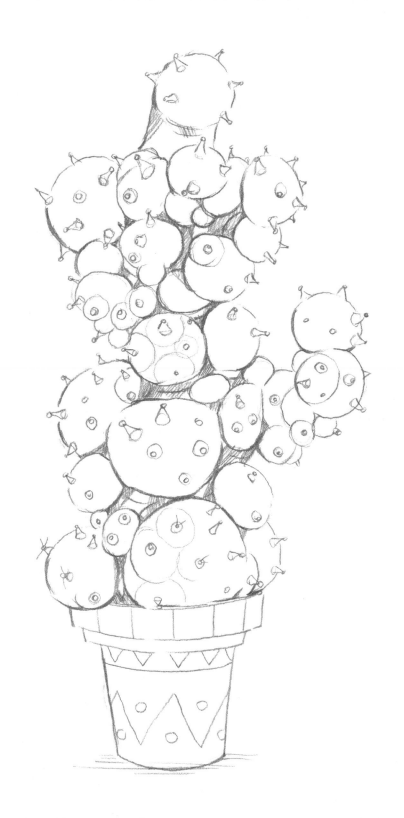

Arnold the Pygmy Puff

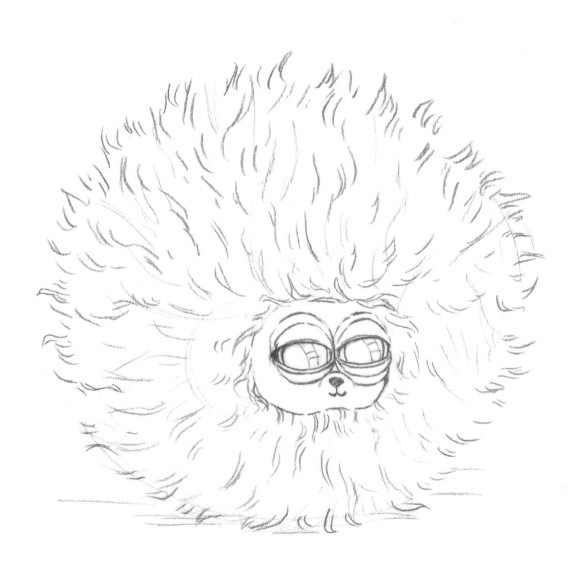

Fang the Boarhound

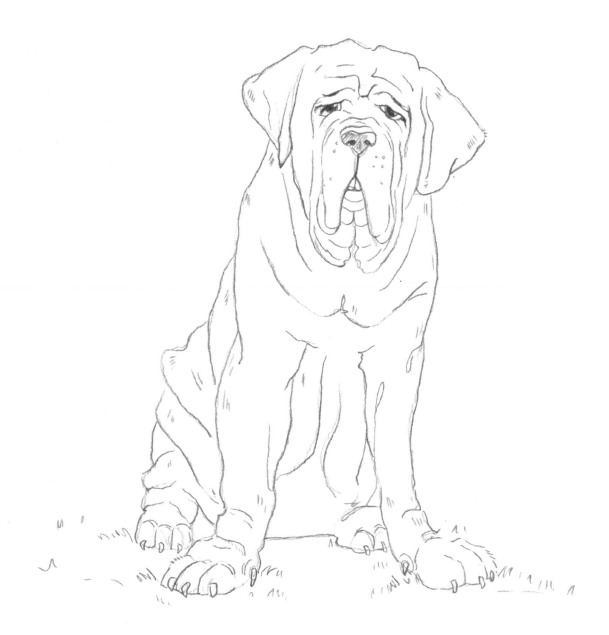

Trevor the Toad

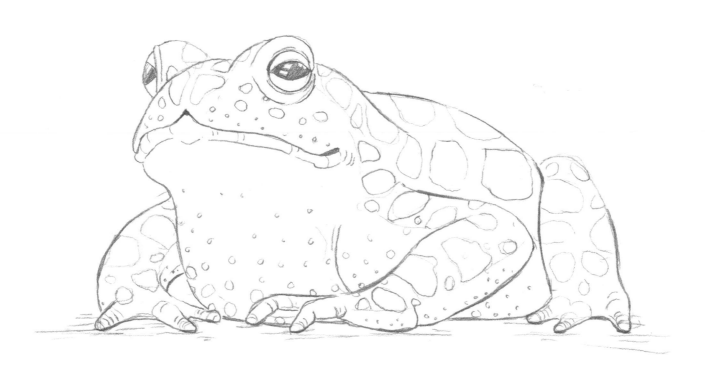

McGonagall as a Cat

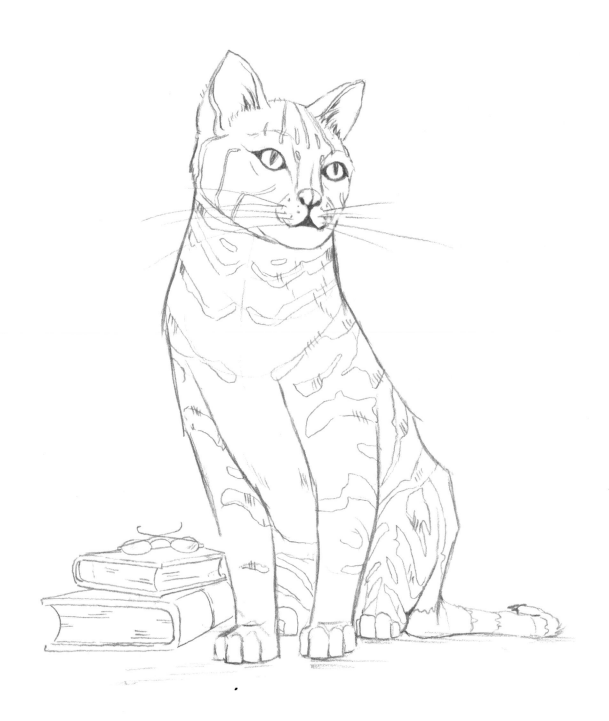

Dirigible Plum Tree

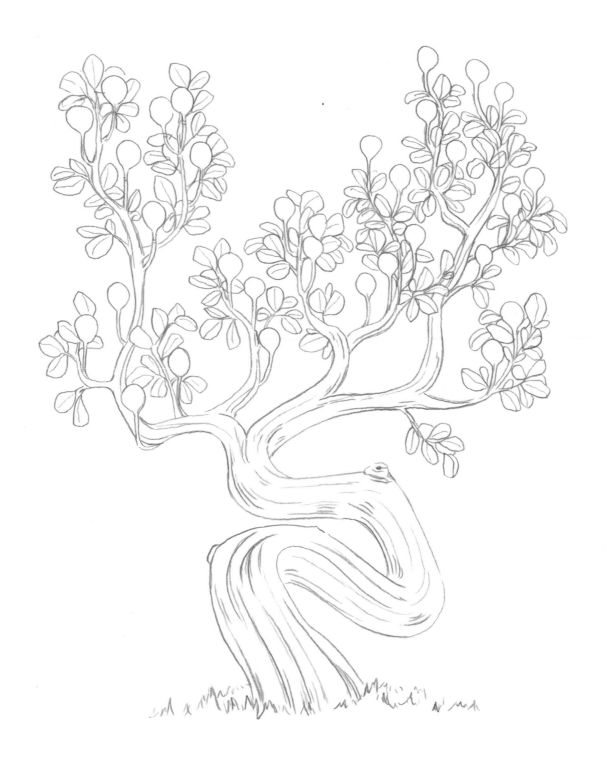

Whomping Willow

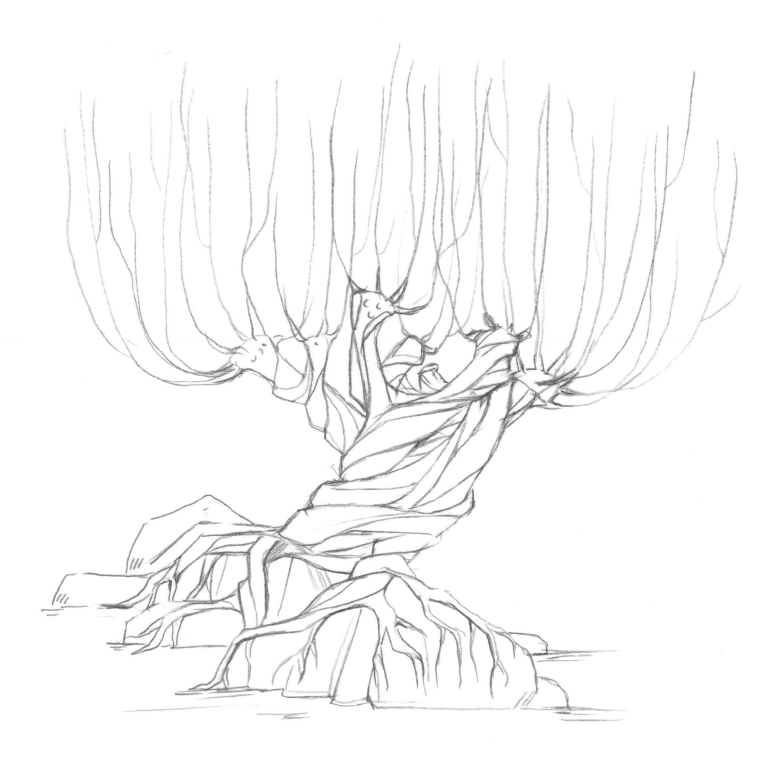

Mandrake

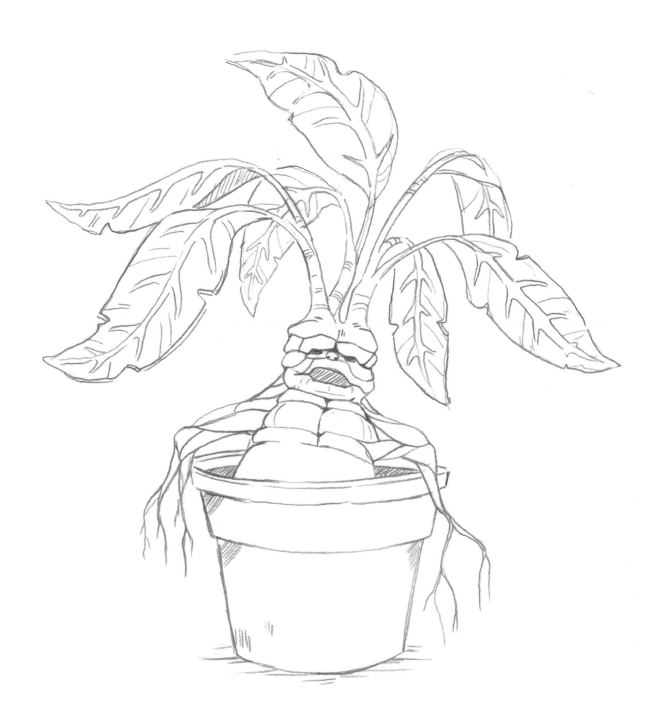

Fluffy the Three-Headed Dog

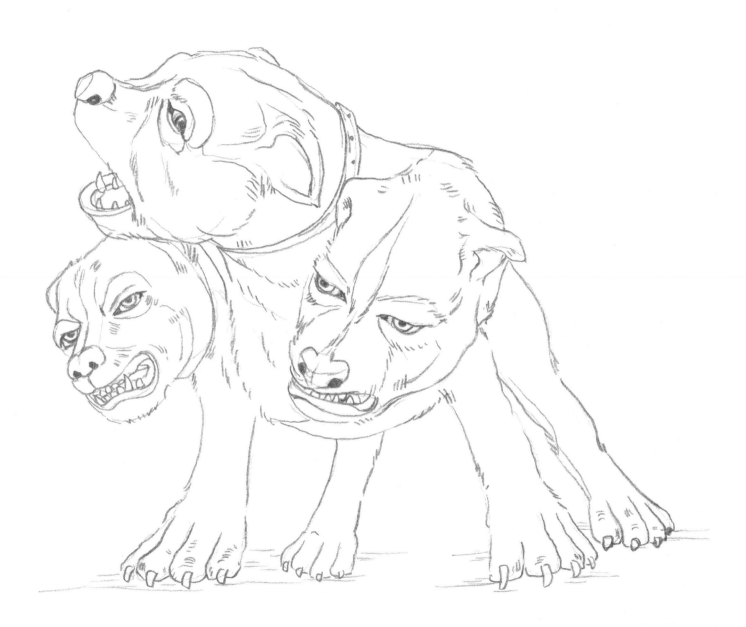

Grindylow

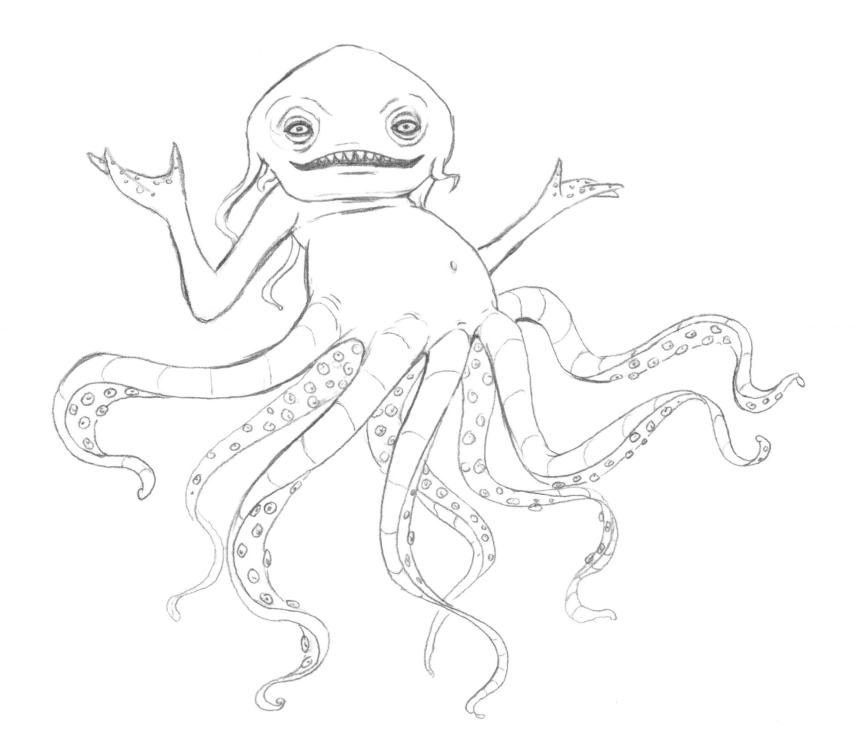

Werewolf

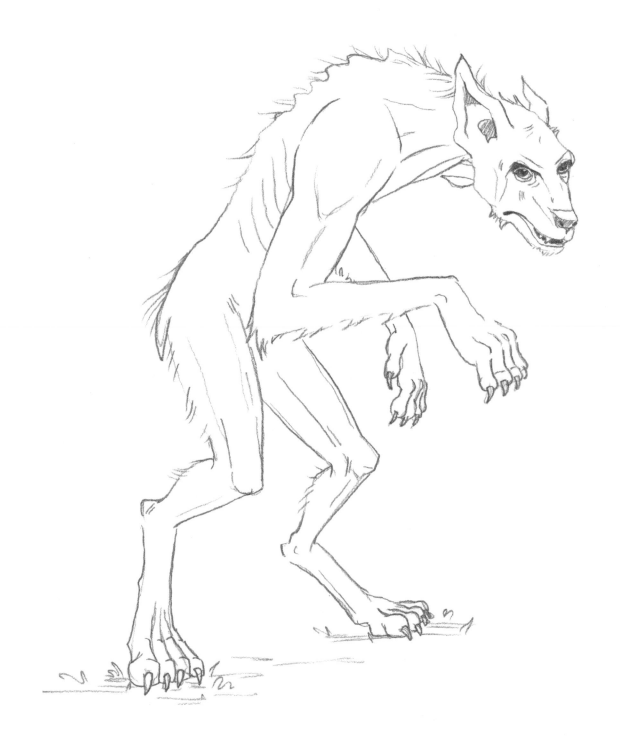

Norbert the Dragon

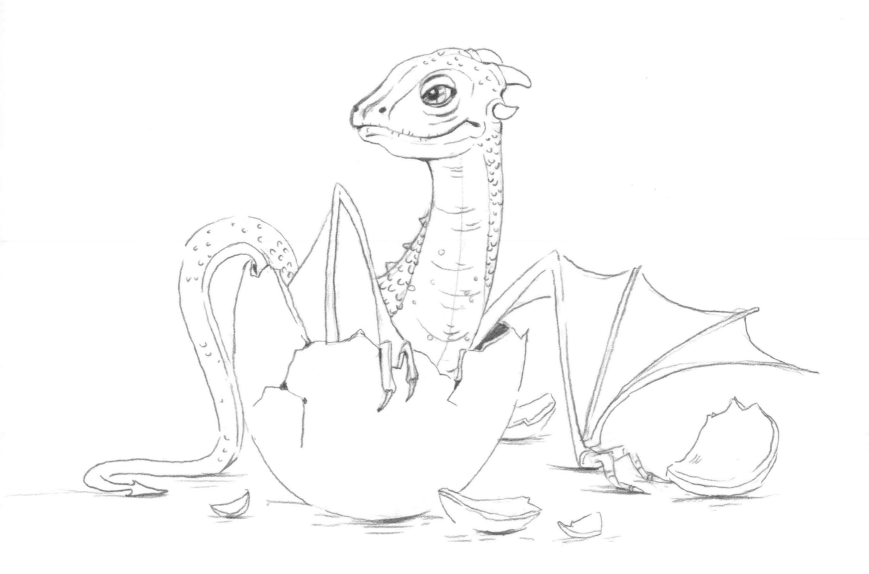

Mountain Troll

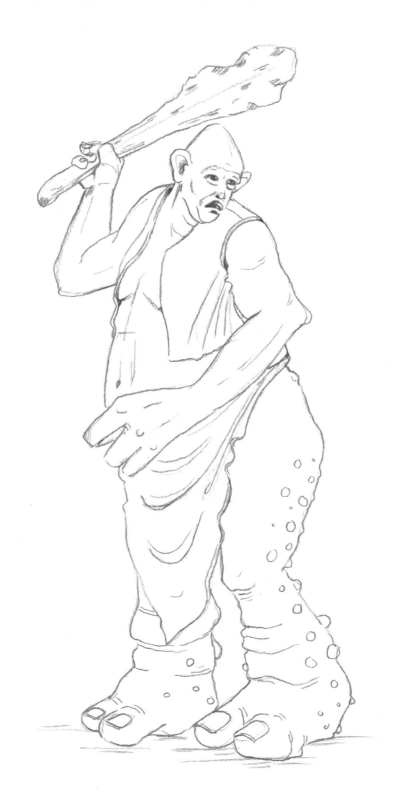

Nagini as a Snake

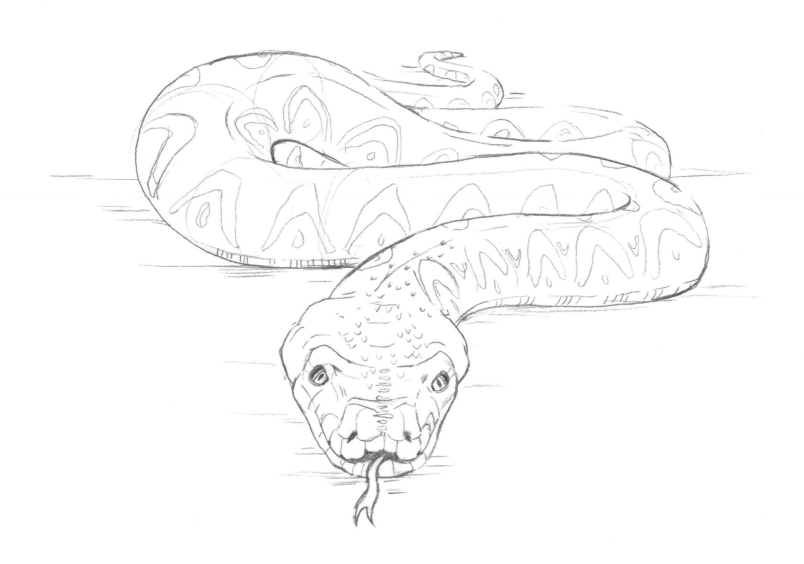

Griphook the Goblin

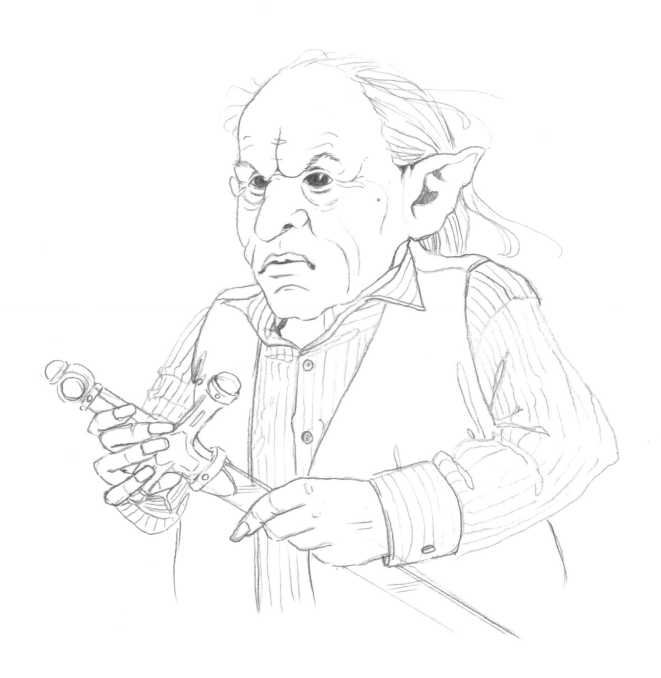

Venomous Tentacula

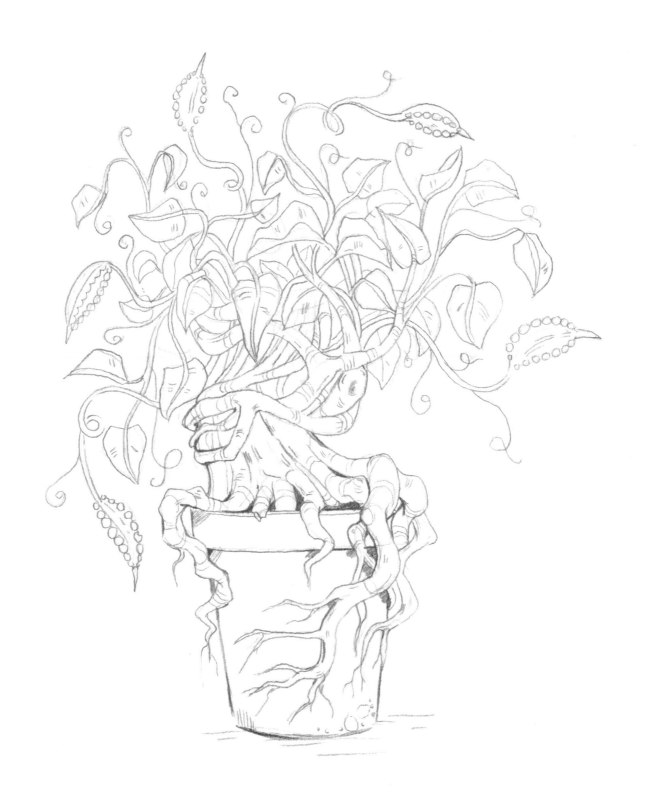

Zouwu

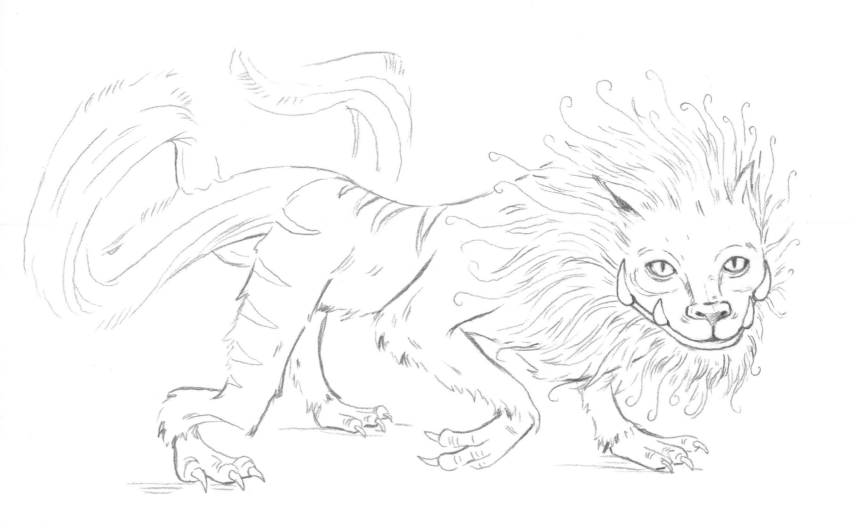

Fawkes the Phoenix

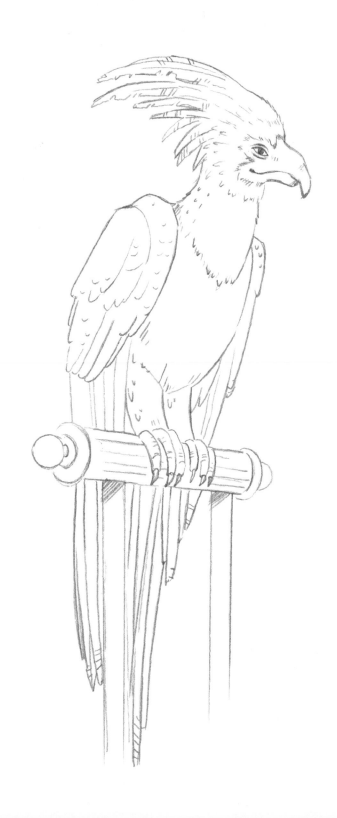

Merperson

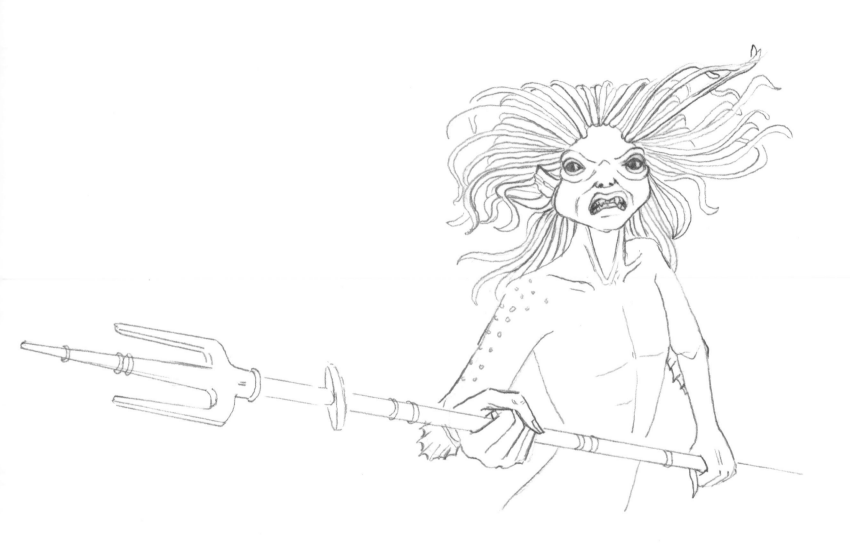

Basilisk

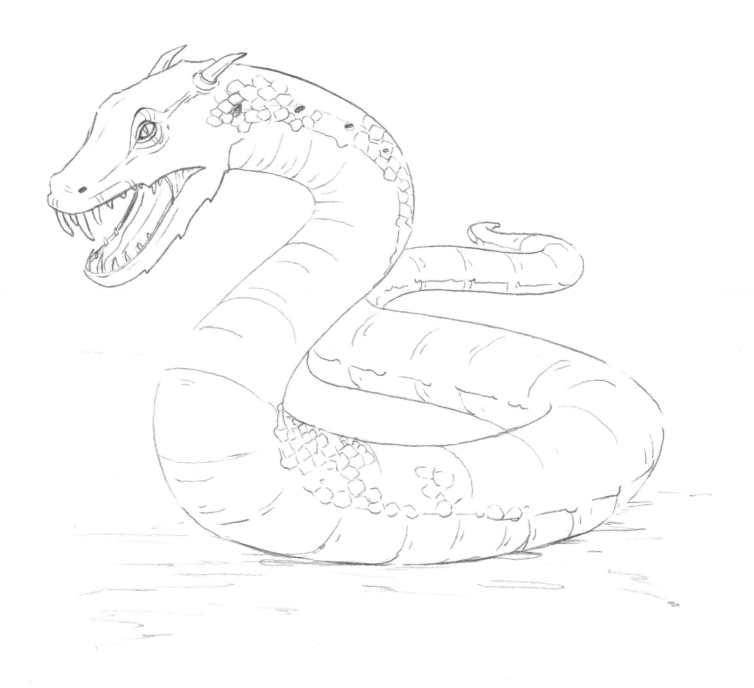

Centaur

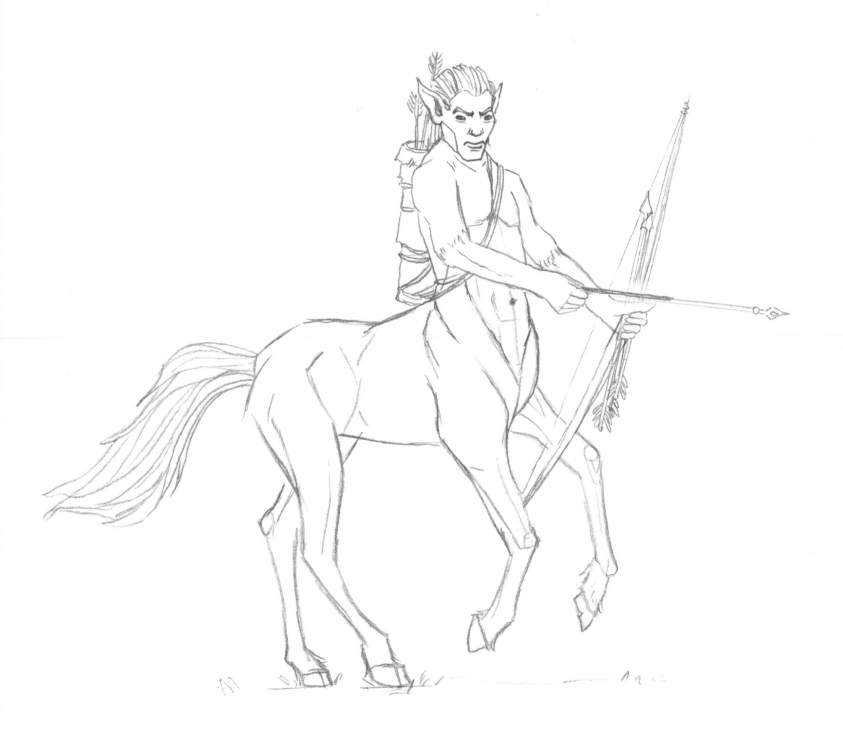

Niffler

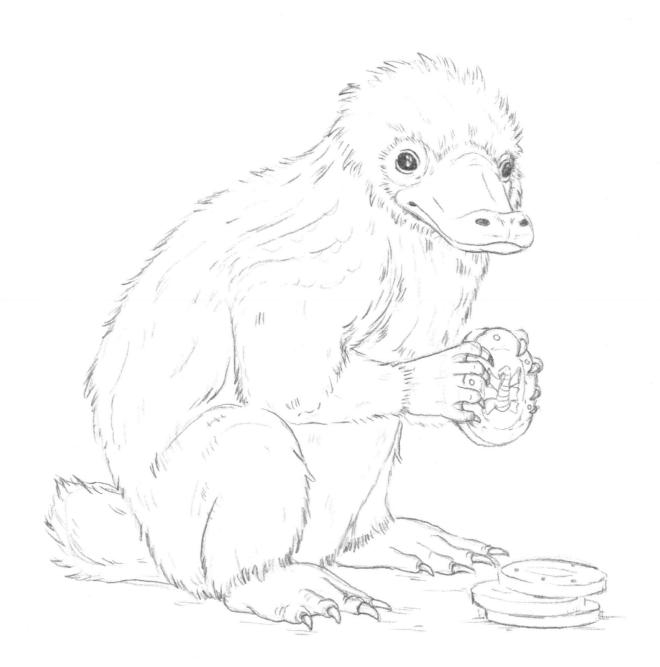

Crookshanks and Scabbers

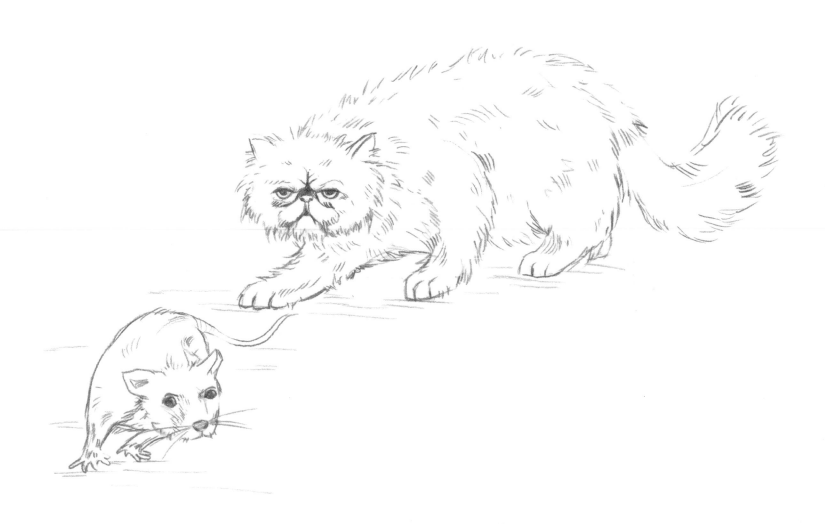

Swooping Evil

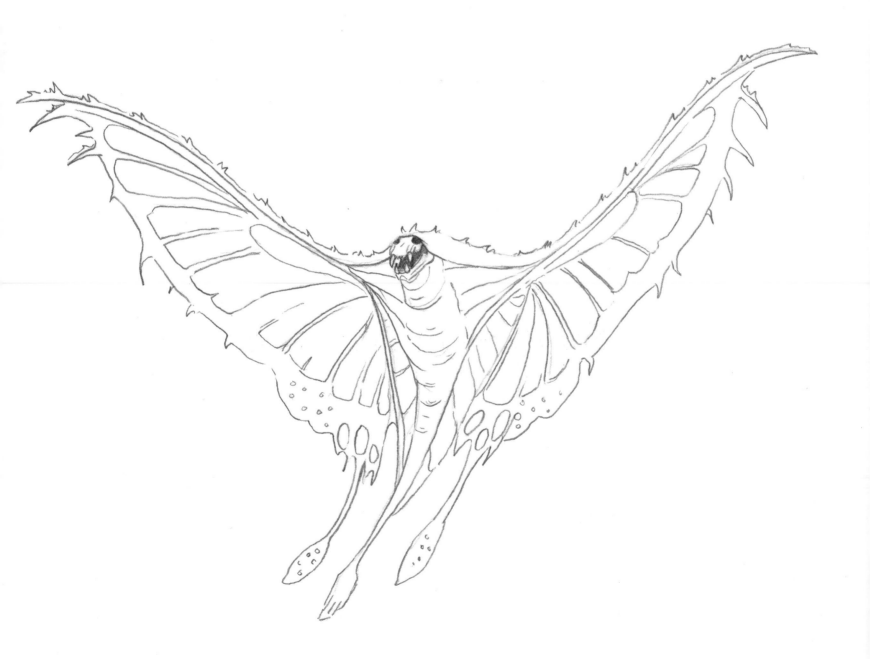

Hungarian Horntail

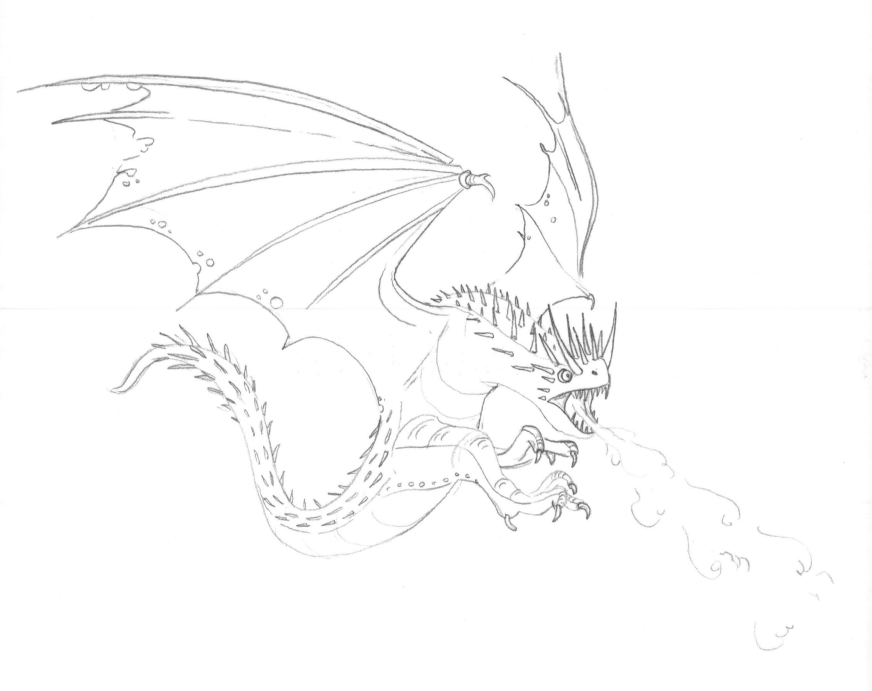

Cornish Pixies

Thestral

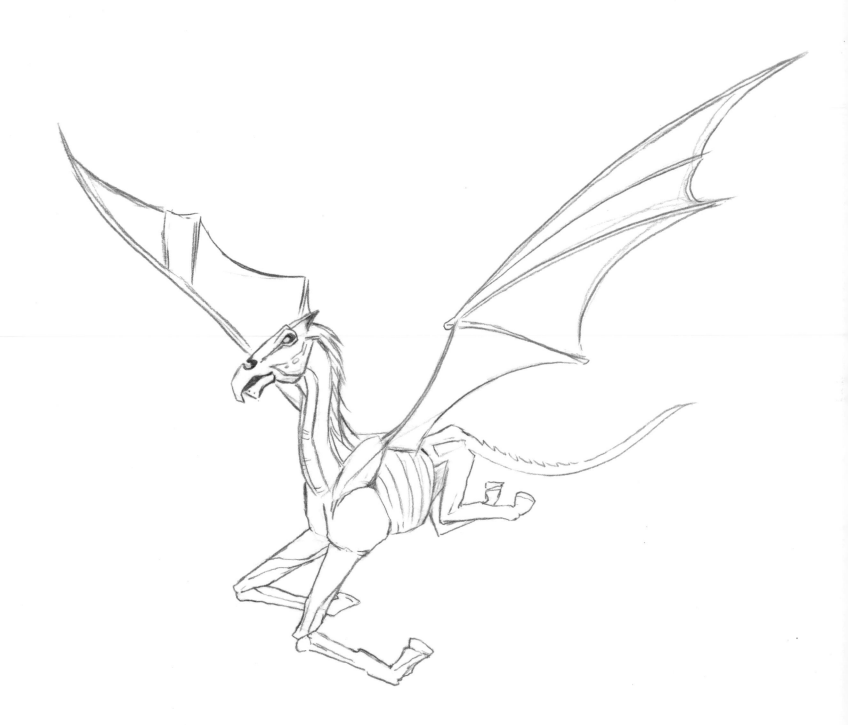

Buckbeak the Hippogriff

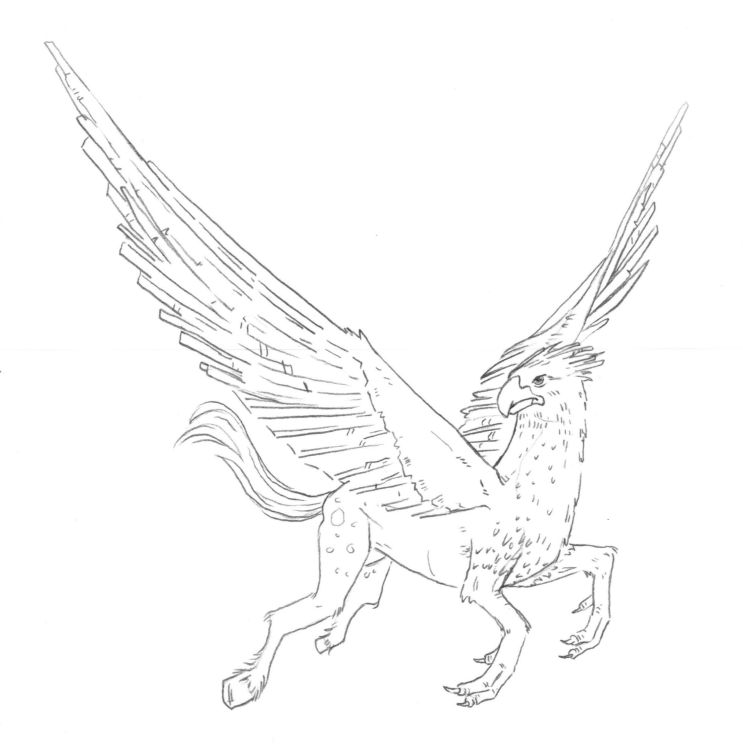